The Quiet Landscapes

of

William B. Post

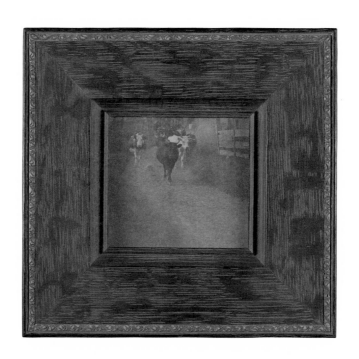

Untitled
c. 1900, platinum print
3 13/16 × 4 1/8 inches
Frame by George F. Of

2002.69.59

The Quiet Landscapes

of

William B. Post

CHRISTIAN A. PETERSON

THE MINNEAPOLIS INSTITUTE OF ARTS

This book is dedicated to Mary Weston, a relative of William B. Post, whose deep interest in Post, careful stewardship of his photographs, and complete cooperation with the museum have made this publication possible.

This publication was produced in conjunction with the traveling exhibition
"The Quiet Landscapes of William B. Post."

The Minneapolis Institute of Arts
Minneapolis, Minnesota
September 10, 2005–January 22, 2006

Cedar Rapids Museum of Art
Cedar Rapids, Iowa
February 17–May 21, 2006

Portland Museum of Art
Portland, Maine
June 3–August 27, 2006

Columbus Museum of Art
Columbus, Ohio
September 16, 2006–January 14, 2007

Brigham Young University Museum of Art
Provo, Utah
February 3–May 28, 2007

Tacoma Art Museum
Tacoma, Washington
June 23–September 16, 2007

Editing: Sandra L. Lipshultz and Elisabeth Sövik
Design: Elizabeth Mullen
Photography: Donna Kelly
Production coordination: Book Productions LLC

© 2005 by The Minneapolis Institute of Arts
2400 Third Avenue South
Minneapolis, Minnesota 55404
www.artsmia.org

Printed by Tien Wah Press, Singapore

Distributed by the University of Minnesota Press
111 Third Avenue South, Suite 290
Minneapolis, Minnesota 55401-2520
www.upress.umn.edu

Library of Congress Control Number: 2004106196
ISBN: 0-8166-4811-5

Cover: *Intervale, Winter*, 1899, platinum print, 7 5/16 × 9 7/16 inches

CONTENTS

PREFACE

THIS MONOGRAPH EXAMINES THE work of one of America's leading artistic photographers at the beginning of the twentieth century—William B. Post (1857–1921). In 1903, Post became a member of the Photo-Secession, Alfred Stieglitz's elite organization of pictorialists, and the publication of his images in the famous periodicals *Camera Notes* and *Camera Work* brought him much-deserved recognition during his lifetime. Since Post's death, however, his photographs have been rarely exhibited and greatly underappreciated. This publication surveys Post's accomplishments and reveals the subtle beauty of his exquisite landscapes.

I first contacted William B. Post's relatives in 1983. Subsequently Mary Weston, whose grandfather was a nephew of Post's wife, initiated a correspondence with me that went on for twelve years before we finally met. In 2000, I viewed nearly eight hundred prints by Post that the family still had in its possession. Our ongoing conversations convinced me of the importance of Post's work and eventually led The Minneapolis Institute of Arts to purchase sixty of his photographs in 2002. This book is the first in-depth study of Post's art and career.

I sincerely thank the individuals who supported and assisted me with this project. First and foremost is Mary Weston, who not only has overseen the organization and safe storage of her great-granduncle's photographs but has shared important archival material on him and answered all my inquiries enthusiastically and thoroughly. The following professionals provided me with useful information as well:

Rachel Stuhlman and Liz Dodds of the George Eastman House in Rochester, New York; Alfred Mueller of the Beinecke Rare Book and Manuscript Library at Yale University in New Haven, Connecticut; Peter C. Bunnell of the Princeton University Art Museum in Princeton, New Jersey; Susan Danley of the Portland Art Museum in Portland, Maine; Tom Gaffney of the Portland Public Library in Portland, Maine; Tanya Semo of the Worcester Art Museum in Worcester, Massachusetts; and Mariam Touba of the New-York Historical Society in New York City. Gina Dabrowski gave me much-appreciated emotional support during the writing of this book. I also acknowledge Harry M. Drake for generously providing the funds to purchase the Institute's master set of William B. Post photographs.

At The Minneapolis Institute of Arts, I thank Evan M. Maurer, former director; Carroll T. Hartwell, curator of photographs; and Caroline Wanstall, administrative assistant. Donna Kelly expertly photographed the Post originals for reproduction, Patti Landres carefully matted and framed the pieces for exhibition, Sandra Lipshultz and Elisabeth Sövik skillfully edited my manuscript for publication, and Elizabeth Mullen ably designed this handsome book. I also express my appreciation to the many other devoted staff members who contributed to the success of this catalogue and exhibition.

Christian A. Peterson
Associate Curator of Photographs

The Quiet Landscapes *of* William B. Post

ON JULY 10, 1894, ALFRED STIEGLITZ, WHILE VACATIONING in Europe, wrote to William B. Post, saying he was going to submit one of Post's photographs to London's prestigious photographic salon when he arrived in England. Photographers usually entered their own work in competitions and exhibitions, but Stieglitz was particularly enthusiastic about Post's picture. "If it doesn't get in," he declared, "I don't know anything about art photography and the [judging] committee will fall considerably in my estimation. I like the picture fully."[1] Stieglitz would soon become America's leading proponent and practitioner of artistic photography, a movement in which Post would also figure prominently.

By the summer of 1894, Stieglitz and Post—who was six years older—were good friends. Stieglitz sent Post at least three letters during that trip abroad, encouraging Post to pursue his own art, lending emotional support, and generally offering help: "Don't be bashful and too modest to ask me to do anything that is in my power for you."[2] Stieglitz, in fact, promoted Post's photographic work for the next fifteen years, publishing it in his magazines and including it in important exhibitions. And while Post's landscapes stand on their own as some of the most lyrical and accomplished creative photographs made around the turn of the twentieth century, Stieglitz's endorsement of them only increased their visibility and influence.

William Boyd Post (1857–1921)[3] photographed from the mid-1880s through the 1910s, the period when serious amateurs first pursued photography as an artistic outlet. Post initially made pleasant images of figures and landscapes in the "naturalistic" style, which celebrated rural living and utilized fairly straight-forward photographic techniques. By 1900, however, he had embraced "pictorialism," a style that featured simple compositions, soft-focus effects, and highly refined printmaking methods. For the next decade, he concentrated on landscapes, specializing in snow and water-lily images. His best pieces were intimate platinum prints that were subtle, poetic, and delicately understated.

EARLY LIFE

LITTLE IS KNOWN ABOUT POST'S life before the 1880's, when he became involved with photography. He was born in New York City on December 26, 1857, to Emeline Flandrau Post (1837–61) and Samuel L. Post, Jr. (1834–97). His mother died when he was only four years old, and his father remarried. He had an older sister, Emma (1856–1923), who married and had five children.

William's name first appeared in the Manhattan directory in 1880, when he was listed as a stockbroker with the firm of Homans and Company. For most of the next twenty years, he lived at 519 Madison Avenue, an upscale apartment building near the corner of 53rd Street. His father and stepmother had the same address, suggesting that Post, who was unmarried at the time, resided with them.

In 1887, following in his father's footsteps, he became a member of the New York Stock Exchange. During his election hearing before the exchange's admissions committee, Post revealed his monetary worth, stating he had assets of at least twenty-five thousand dollars, equivalent today to about half a million.[4] Financially secure and living comfortably, Post worked as a stockbroker for the next ten years, both with Wall Street firms and on his own.

BEGINNINGS IN PHOTOGRAPHY

POST WROTE VERY LITTLE ABOUT photography and never explained why he became interested in it. In the mid-1880s, when the medium caught his attention, many men of means regarded photography as a challenging diversion from the duties of family and work, which was probably Post's motivation as well. At that time—before the existence of the Kodak camera and the proliferation of snapshot equipment—photography required much of its devotees. Even amateurs had to develop their own negatives and make their own prints, procedures necessitating time, money, and scientific knowledge.

In 1910, Post stated he had been photographing for twenty-five years, which would indicate he had begun around 1885, when he was in his mid-thirties. The earliest references to Post's photographic activity occur in 1888, when he was a member of two camera clubs in

New York. In November of that year, the Society of Amateur Photographers of New York opened a members' exhibition of nearly six hundred prints, including eight by Post. The society was New York's most prominent club at the time, with about 250 members, among them such leading figures as Catherine Weed Barnes and John E. Dumont. Post held his own in the exhibition with images that *Anthony's Photographic Bulletin* characterized as "excellently done."[5]

In 1888, Post also became a member of the New York Camera Club, which formed in November that same year. He attended the club's first official meeting, where "evening dress was observed" and the president announced the organization's membership had already grown to fifty-five.[6] The club, which rivaled the Society of Amateur Photographers, was established by a handful of individuals who broke away from the society because it allowed professionals to join. Most members of the fledgling New York Camera Club, by contrast, wished to associate only with fellow amateurs, who made pictures solely for personal pleasure rather than financial gain (the true definition of an amateur). Post, however, never quit the Society of Amateur Photographers, enjoying the benefits of belonging to both groups.

Over the next few years, Post's photographs received increasingly significant notice. His first published work (fig. 1) appeared as the frontispiece in the January 18, 1889, issue of the *Photographic Times*, a well-respected journal

in the field. The magazine featured very few illustrations and had only recently begun using the high-quality photogravure process to print them. Post's *Study from Life*, reproduced in green presumably because of its outdoor setting, shows a well-attired woman in a stand of trees, which seem to physically support her while creating an effective frame. The image typifies the kind of portraits and figure studies Post was making at the time.

Later in 1889, Post presented similar pictures in the annual Joint Exhibition, an important collaborative effort between camera clubs in New York, Boston, and Philadelphia. *Anthony's Photographic Bulletin* described his work first in its review of the show: "W. B. Post, of the New York Camera Club, has several excellent outdoor portraits taken with foliage backgrounds, that were very effective and picturesque."[7]

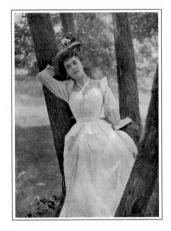

Fig. 1. William B. Post, *A Study from Life*, 1888 or earlier, photogravure, published in *Photographic Times*, January 18, 1889

TRAVELING IN CALIFORNIA AND JAPAN

DESPITE HIS GROWING CELEBRITY, Post was absent from photographic circles during most of 1891 because of a nine-month trip to California and Japan. Although he photographed along the way, encountering new and spectacular subjects, his main reason for the journey was physical. During his travels, he kept a daily journal, where he plainly stated he "was away for health rather than sight seeing." [8] The only ailment he repeatedly mentioned in his diary was catarrh, a chronic inflammation of the mucous membranes, which is often caused by allergies. Post's doctor might have suggested the change of climate to provide relief. According to Post's diary, he also sailed to Bermuda once, probably for the same reason.

In the early 1890s, both California and Japan were considered alluring destinations for travelers. California was known for its awe-inspiring natural beauty, had a booming farm economy, and was becoming home to many artists. By 1891, Japan had modernized and become a world power economically and politically. Americans went there in great numbers and found much to admire, from its mountainous terrain to its refined art, architecture, and crafts. Post, in fact, had easy access to Japanese culture even before he made his trip. The year before, both *Wilson's Photographic Magazine* and the *Photographic Times* printed articles about professional and amateur photography in Japan. And in

January of 1890, the New York Camera Club sponsored a lecture by a former member of the Japanese Imperial Board of Education, who showed slides of the country's landscape, buildings, and people.

Post began his long journey by train, leaving New York on January 7, 1891. At first, he headed south, to New Orleans, and then west, to San Antonio, spending several days in each city. Because he had the money to travel in style, he always booked the finest train and hotel accommodations available. The first train he boarded was "most elegant in all its appointments, consisting of a combination library, lounging, and café car, three sleepers and also one day coach." "I cannot imagine anything more complete from the Pullman shops," he wrote. [9] During his time in New Orleans, he stayed at the St. Charles, a luxury hotel that was the largest in the city.

Post photographed various subjects during his two-week trip to California. Although initially the speed of the train prevented photographing, he did make a few exposures of oxen on the third day out. In New Orleans, he took pictures of the business district, French market, slums, and levees. In San Antonio, he shot the picturesque ruins of the Alamo and other Spanish missions. On the last leg of the trip west, he became fascinated with the Native Americans he saw along the route and in Arizona got out at some stops to photograph them.

Post arrived in Los Angeles on January 21 and remained in California for the next four and a half months. Starting in the south and working his way north, he spent a week or two in most of the major coastal cities, including San Diego, Los Angeles, Santa Barbara, Monterey, San Jose, and San Francisco. In his journal, he wrote about his photographic activities, the California landscape, the acquaintances he made, his accommodations, and the food.

In San Diego, for instance, he told one desk clerk he was "a gentleman of wealth and leisure" to ensure he was given a good room.[10] He also noted that the hotels where he stayed had other sophisticated guests from New York and Boston and offered such amusements as classical concerts. Usually, however, he was disappointed with hotel food, uniformly calling it "a bad table." Consequently, he was overjoyed one evening in San Francisco when he was served the best French meal he had ever eaten, an occasion he described in detail in his journal.

He was thrilled with California's native plants. He noted the south's citrus, olive, and oak trees and its multitude of cacti. Riding north on the train, he frequently got off at stops to pick poppies, buttercups, violets, and daisies. In April, he spent nine days in San Jose, where he admired the city's blossoming roses and its eucalyptus, pepper, and palm trees. Shortly thereafter, he observed two hundred varieties of orchids and Japanese trees at a conservatory in San Francisco and reveled in the beauty of wildflowers in San Rafael. Frequently in his diary he even recorded the type of cut

flowers displayed at his hotels. Not surprisingly, nature became one of his primary photographic subjects while he was on the West Coast.

Post enjoyed good company while in California and met such famous people as the American landscape painter George Inness (1825–94). Inness, also visiting from the Northeast, was at the height of his career, producing delicately composed, darkly atmospheric canvases that many pictorial photographers admired. Exactly twice Post's age, with a bombastic personality, the sixty-six-year-old painter undoubtedly presented an imposing figure to the younger man. On March 3, Inness accompanied Post to the countryside for the first time, where he helped him compose scenes of trees and farmsteads near Pasadena. "Some of the finest landscape comositions I have ever made," Post reported in his journal the next day.[11] These pictures probably included *A Pasadena Landscape* (fig. 2), which dates from that time.

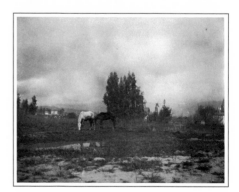

Fig. 2. William B. Post, *A Pasadena Landscape*, 1891, photogravure, published in *Camera Notes*, January 1898

Naturally, Post kept track of his other photographic experiences in California as well, and they were not all good. In February, just a month before his outing with Inness, he had so many difficulties it shook his confidence as a photographer. He decried the abundance of Kodak cameras, dealt with defective plates, and struggled with reflected light while photographing the sea. "Again I have failed to get good results," he wrote, "and am commencing to feel that I am either a fraud or am losing my grip on photography." [12]

But he persisted and over the next few months made hundreds of successful exposures: of Mount Baldy near Los Angeles, the main street of Riverside, fishermen with their nets at Redondo Beach, and missions in San Gabriel and Santa Barbara. In early April, he spent a week in the Monterey area, where he photographed Cypress Point and Point Lobos, decades before Edward Weston would. Finding the surroundings "the grandest scenery in the shape of rocks and water" he had ever seen, [13] Post spent hours near the surf and one day almost lost his camera to a particularly large wave.

In late April, he arrived in San Francisco, his base for the next five weeks until his departure for Japan. Early in his stay, he made his way to the studio of Isaiah W. Taber, a well-known American photographer who took Post's portrait. He also received advice about photographing in Japan from one of Taber's assistants who had already been there. The highlight of Post's time in northern California, however, was a week-long stay in Yosemite,

which had just been designated a national park and could only be reached after two treacherous days by stagecoach. In Yosemite, Post again enjoyed the company of George Inness, along with William Keith (1839–1911), a Barbizon painter who had settled in San Francisco. Together the three took long walks, watched sunrises, and made their artwork. At first, Post was overwhelmed by the bigness of the valley, a usual reaction to the grandiose landscape. A few days later, however, he wrote that he had "seen . . . many fine pictures and beautiful scenes in the valley," had reconciled his "sense of smallness in the presence of such mighty work," and could "fully appreciate the Yosemite." [14]

Post regularly developed his own negatives throughout the trip. This allowed him to check his equipment, monitor his artistic progress, and send successful negatives back to New York for safekeeping. In the 1890s, because of the increased popularity of photography, some hotels provided darkrooms for their guests. Post, however, seems to have preferred working in his own bathroom. In Monterey, for instance, he developed film in his hotel room and had to pay an extra fee for supposedly damaging the bathtub.

But in San Francisco, he turned over much of his Yosemite film to a professional photographer because he had more than he could develop before leaving for Japan. Unfortunately, the man ruined most of the exposures, leaving Post with only a few usable shots and prompting him to vow to never again allow someone else to develop his film. By then, Post had already made at

least five shipments of successful negatives back to New York. And by the time he left for Japan, he had sent more than eight hundred glass-plate and film negatives to a fellow member of the Society of Amateur Photographers to hold until his return.

The day Post sailed for Japan he spent the morning with William Keith, whose company he had come to prefer to Inness's. Having worked side by side in Yosemite the month before, Post and Keith had grown to appreciate each other's landscapes. The younger Post proudly recorded in his journal that Keith had even painted a canvas from one of his photographs and that the two were going to trade work. However, because of the difference in their artistic stature and in the perceived value of their media, Post exchanged one hundred photographs for one small painting.

On the afternoon of June 2, 1891, Post boarded the *City of Peking* for Japan. The ship, a steamer with sails, was modest in size but had large, comfortable staterooms, and Post was one of only seventeen passengers (half of them Japanese) with private accommodations. Early in the voyage, he wrote in his journal that he was feeling lonely and mentioned having thoughts about a particular woman. He also made brief entries about the cold rainy weather, the ship's slow progress and compass locations, and the fact that he avoided serious seasickness by eating frequently. Despite having his own room, he spent considerable time on deck and in steerage, which was crowded with Chinese passengers. There, he watched children playing and adults gambling and smoking opium.

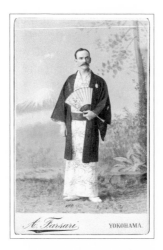

Fig. 3. A. Farsari, *Portrait of William B. Post*, 1891, albumen print, collection of Mary Weston

Unfortunately, an elderly person in steerage died nearly every day during the crossing, producing a store of bodies that were kept on board for burial in China.

After two long weeks, Post finally arrived in Yokohama on June 19, eager to set foot on land. Two days later, he expressed his pleasure at what he had already seen. "I would not have missed this trip for half of what I am worth and to say that I am glad I came does not express it. Japan, the land of bronze and lacquer, the most beautiful country in the world, is a lasting delight."[15] Restricting his visit to east central Japan, he spent time in Tokyo, Kyōto, Nagoya, and several other places. He particularly enjoyed Miyanoshita, a small town nestled in lush green hills with a commanding view of Mount Fuji. In Yokohama, at either the beginning or the end of his trip, he also

had a full-length portrait made of himself in traditional Japanese garb (fig. 3).

During his three months in Japan, Post observed the culture, the landscape, and everyday life. His journal entries reveal that he was immediately impressed with the strength of rickshaw drivers and the perfect complexions of the women. He noted the way female workers washed wooden floors with their bare feet and how rice was frequently transplanted during its growing season. And he enjoyed the sound of wooden shoes, the light from paper lanterns, and boat rides in sampans and junks.

Not surprisingly, he paid particular attention to nature, listening to birds and viewing acres of rice paddies, bamboo groves, and tea plantations. He considered Japanese tiger lilies, water lilies, and lotus flowers among the best he had ever seen and found the country's ferns, shrubs, and trees magnificent. Only Japanese butterflies, with their exquisite coloring, enchanted him more.

He was most enthralled, however, by Japanese art. He marveled at the rich costuming and simple sets of the theater and at the supple movements of the performers. He went to temples and shrines in Nikkō and saw unparalleled examples of exquisite carving, painting, and lacquerwork. In late July while in Kyōto, he spent several hours watching potters shaping and glazing their pieces. He also visited a cloisonné factory, where he was struck with the patience and endurance of the artisans, who were creating objects for both the emperor and an upcoming

world's fair. "Fine work of every description is done by hand in Japan," [16] he observed in his journal, and among the many handcrafted objects he purchased were a cloisonné vase, a cloisonné box, an ivory carving, several ceramic tea sets, and a silk kimono. The kimono he bought in Tokyo was of such high quality that even the Japanese maids at his hotel admired it.

While in Japan, Post had mixed success with his camera. He used cut film instead of glass plates (probably to reduce the weight of his luggage) and apparently did not develop his own negatives. During his first week in Yokohama, he exposed about fifty sheets of film, which he then had a local photographer develop despite his disaster in San Francisco. Incredibly, once again, his film was ruined. "I am in despair about my pictures," he wrote on June 27, "I cannot afford such a slaughter." [17] Consequently, he was faced with a dilemma: either have no more negatives developed (which would have prevented him from ascertaining his progress) or risk further loss. Ultimately, he compromised and had some film developed in Japan and the rest processed after he returned home. The weather in Japan also hampered his photographic work. He was there for part of the rainy season, and much of the summer was hot and humid, conditions that warped his wooden camera and film holders and also affected his film.

Despite these setbacks, Post continued to photograph during his visit. In mid-July he bought a one-week pass to the temples in Nikkō, which allowed him

to photograph the buildings' interiors as well as their exteriors. A few weeks later, he also reported making a good set of exposures in Nagoya of unspecified subjects. In August he worked along the coast, capturing images of the water and of women and children digging for clams.

A few weeks before he left Japan, Post indicated he had exposed about five hundred sheets of film, both 4-by-5-inch and 5-by-7-inch. Nevertheless, he felt dissatisfied. "The variety of pictures I might have had causes me much regret; as I consider my collection, especially in genre and character studies, very incomplete." [18]

Also incomplete is Post's written account of his experiences in Japan. Diary pages for fully half of his nearly ninety days there are missing. Careful reading of what remains suggests he might have witnessed or indulged in things that someone, in hindsight, considered unseemly. Post's entry on July 10, for instance, follows a gap of ten days and notes that he was leaving the town of Miyanoshita and parting from two other Westerners because of their behavior. "They are good company for me and I like them very much but they are a trifle too new and fool with the Jap girls too much and get drunk too often. It is a great loss to me but I do not wish to figure on the police books or get in a scrape in Japan." [19] Also gone are entries for his last three days in Japan, a time that certainly included farewell celebrations. Since Post was single during the trip, he might have removed certain pages after he married

to spare his wife's feelings, or she might have done so after his death to protect his reputation.

Post set sail for home on September 12 on the *Empress of China*, leaving Yokohama under a blazing sunset. His return trip was less eventful than the voyage over and, like the earlier passage, provided few opportunities for picture making. He noted in his journal that there were many more first-class travelers than on the ship to Japan but that, ironically, the food was poorer. In less than two weeks, his steamer docked in Victoria, British Columbia. From there, Post took another boat to Tacoma, Washington, and then quickly made his way back to New York by train. Apparently, he did not take any photographs along the way, although he did stop briefly in Portland, Oregon, where he attended a regional exposition, and in San Francisco, where he made no journal entries detailing his activities.

Post arrived back in New York City on October 6, nostalgic for Japan and happy he had gone. "My first outing has given me a taste for travel," he wrote, "and my camera has cultivated my love of the beautiful in nature." [20] He was so invigorated by the journey that he expressed a desire to continue enriching his life with additional trips, though of shorter duration. Within the next eighteen months, he did go to the Bahamas and took photographs of Nassau. But other than that, Post never left the United States again, not even to go to Europe, and always preferred staying close to home.

Post's travel pictures seemed to have been jinxed, for he had a third and final mishap with them after he returned to America. In late 1891, *American Amateur Photographer* stated that Post had sent a large group of negatives to the Eastman Kodak Company for developing after "receiving personal assurance from a member of the company that especial attention and care would be given to his work." Nevertheless, "Mr. Post reports that only eighteen out of the 300 were perfect, the balance while good otherwise were all more or less defaced by hypo stains, thumb and finger marks and scratches due, he has no doubt, to careless handling in development. Thus some of his best and most valuable work was spoiled."[21]

Despite his bad luck with his travel photographs, Post did produce some satisfactory images of Japan, which he exhibited and saw published shortly after his return. On the evening of February 12, 1892, for instance, he showed slides of his trip to fellow members of the Society of Amateur Photographers of New York. And over the next few years, *American Amateur Photographer* featured half a dozen of his Japanese subjects, including views of Yokohama and portraits of young women. But judging from these images, Post used the camera more like a tourist than an artist, a fate that often befell photographers traveling to exotic places and those who were still formulating their creative vision.

ESTABLISHING A REPUTATION

IN 1893, POST BECAME INCREASINGLY involved in photography. He was active in the New York camera clubs, maintained a friendship with Alfred Stieglitz, exhibited internationally, and received recognition for his artistic accomplishments.

At the time, membership in a camera club was considered essential for any amateur who wished to make more than mere snapshots. The average camera club provided both a physical facility that was beyond the means of most beginners (i.e., a darkroom, portrait studio, library, and gallery) and a congenial atmosphere that

was conducive to aesthetic growth. Members shared information, went on photographic excursions together, and, through good-hearted competitions, encouraged one another to do better work. The most active clubs held meetings (often once a week) devoted to talks on art, critiques of members' work, lessons on photographic technique, and social events such as "smokers." Photographic magazines told photographers how to organize clubs and emphasized that, to succeed, officers had to work hard and members needed to participate. In 1891,

the *American Annual of Photography* listed seventy-five camera clubs in the United States alone, from the Agassiz Association Photographic Section, a scientific society in Manhattan, to the Zanesville Camera Club, a small group of amateurs in southeastern Ohio.

Post was well aware of the advantages of membership in a camera club and became increasingly active in the Society of Amateur Photographers of New York. In March 1893, he served on the organizing committee for the society's annual members' exhibition and was the leading exhibitor in the show. He won more medals than anyone else, taking one in every category except science. A few months later, Alfred Stieglitz, a fellow member of the exhibition committee, declared, "W. B. Post is without doubt one of the most talented men in the society." [22]

In 1893, Post entered the international arena of creative photography by having work in at least eleven exhibitions abroad, more than all his previous showings combined. This flurry of activity prompted him to begin keeping a log of the photographs he had submitted for consideration and had had accepted. [23] In 1893, he exhibited in Paris, Hamburg, Geneva, Madras (India), and five locations in England. In the United States, he showed at the annual Joint Exhibition, the country's leading series of photography shows, organized by camera clubs on the East Coast. There, and probably elsewhere, Post chose to show primarily images he had taken in California and Japan.

By the end of the year, he had established a reputation as one of America's leading amateur photographers. In December 1893, *American Amateur Photographer* recognized him as such in its short-lived series "Prominent Amateur Photographers," which ultimately included only thirty-six individuals from the United States and Europe. Unfortunately, the magazine devoted no text to those so honored but did reproduce a photograph of each person. Post was represented by a full-length portrait showing him casually dressed and jauntily posed, while most of the other photographers chose rather staid images of themselves. Post was in good company, sharing recognition with such notable figures as Stieglitz, George Davison, John E. Dumont, and Rudolph Eickemeyer, Jr.

THE HAND CAMERA

IN 1888, GEORGE EASTMAN OF Rochester, New York, invented the Kodak box camera and two years later introduced the Brownie camera to the American public, making it possible for anybody to take photographs. Previously, only professional photographers, who used large cameras on tripods in their studios, or serious amateurs, who had similar equipment but often ventured outdoors, could make photographs. Kodak cameras immediately became popular because they were small, portable, and allowed the novice to easily take snapshots. During the 1890s, one and a half million of these "hand cameras" were sold in the United States, a craze matched only by the contemporaneous mania for bicycles.

Initially, serious amateurs like Post were unimpressed with the quality of the box cameras and the pictures they produced. Soon, however, a few manufacturers began fabricating better, slightly larger hand cameras that these practitioners found acceptable. Creative photographers enjoyed the spontaneity afforded by not having to use a stationary camera, and with the medium-format hand cameras, which turned out 3¼-by-4¼- or 4-by-5-inch negatives, they could make quality images. The photographic press conceded that such cameras could be used for artistic results, running articles like "Hand-Camera Memoranda for Pictorial Purposes."[24] In 1895, even the English art photographer

Henry Peach Robinson concurred: "The hand camera is a splendid tool when used seriously."[25]

Post apparently began using a hand camera in the early 1890s. Unfortunately, his diary entries from California and Japan do not indicate what kind of equipment he used on that 1891 trip. But he definitely had a hand camera with him when he went to Nassau in late 1892. A year later, an image he made there won third prize in a competition that the *Photographic Times* held exclusively for hand-camera work. Post's picture, showing a docked sailboat at sunset, was one of nearly seven hundred entries judged by

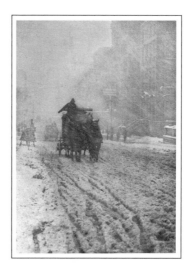

Fig. 4. Alfred Stieglitz, *Winter, Fifth Avenue,* 1893, photogravure, published in *Camera Work,* October 1905

a jury of three that included Alfred Stieglitz, also a recent convert to the hand camera.

It was Post, in fact, who first showed Stieglitz the hand camera, when they were both members of the Society of Amateur Photographers of New York. After impressing Stieglitz with his new equipment and the resulting prints, Post offered to lend him the camera. "The temptation was too great to resist," Stieglitz later recalled. "I had certain things in mind that I knew could not be done with the large camera and tripod."[26] Venturing out from the club's rooms on February 22, 1893, Stieglitz used Post's camera to make *Winter, Fifth Avenue* (fig. 4), one of his early landmark images. Stieglitz was so pleased with the success of this picture and other winter scenes he made with Post's equipment that he quickly purchased a hand camera for himself.

Interestingly, Post, too, created a winter image of a horse-drawn coach on Fifth Avenue with his hand camera (fig. 5). Working just four blocks north of where Stieglitz photographed, Post made his picture at the corner of East 39th Street. Like Stieglitz, Post framed the carriage in the middle ground approaching the camera at a slight angle. But Post maintained the

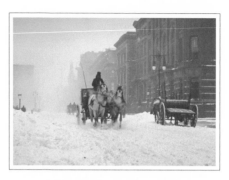

Fig. 5. William B. Post, *Winter on Fifth Avenue*, c. 1893, lantern slide, collection of Mary Weston

horizontal format of his original negative, whereas Stieglitz cropped his, creating a vertical image that was more forceful. While Stieglitz probably made his picture first, the fact that Post's is undated makes it impossible to know for certain.

During the 1890s, Post preferred the hand camera for photographing people, ships, and other moving objects. A few months after he and Stieglitz made their winter scenes of Fifth Avenue, Stieglitz openly recognized Post's abilities and praised his work. "He has already gained distinction abroad and at home for his hand-camera work and slides, in both of which branches he excels," Stieglitz wrote in June 1893. "His hand-camera work is of high artistic merit."[27]

LANTERN SLIDES

POST USED THE MAJORITY OF the negatives he took with his hand camera to make lantern slides, the photographic medium many serious amateurs preferred during the 1890s. Lantern slides are small glass transparencies that were used for public screenings and entered in artistic competitions. Post's slides measured 3¼ by 3¼ inches or 3¼ by 4 inches, with the images masked to smaller sizes, and bore his name on printed labels. Post's earliest dated lantern slide, a picture of three seated women, is from 1888. His *Winter on Fifth Avenue* exists only in slide form.

Post presented his glass slides in many competitions, exhibitions, and screenings throughout the 1890s. According to his exhibition log, he sent slides to Canada in 1894, to India in 1896, and to England in 1893, 1894, 1896, and 1897. In this country, he won medals in competitions sponsored by *American Amateur Photographer* and the *Photographic Times*, with slides of landscapes, flowers, seascapes, and genre scenes. And he often showed his slides at the two New York camera clubs to which he belonged.

Both the Society of Amateur Photographers and the New York Camera Club devoted a great deal of time and energy to lantern slides. They held demonstrations on how to make the slides, provided equipment for producing them, and regularly screened them. The more active Society of Amateur Photographers showed slides once a week and allowed its members to "test" their images to see how they looked projected. The society also presented finished work in a variety of programs as well as in individual and group exhibitions. And as a member of the American Lantern Slide Interchange, the society brought in examples from other clubs to compare with its own.

Post was an early leading maker of lantern slides at the Society of Amateur Photographers, and he served on the lantern slide committee of the New York Camera Club. In early 1892, he presented a one-person show of his slides at the society and later that year had them included in the members' exhibition. In reviewing the group show, *American Amateur Photographer* credited Post with possessing "the rare gift of selection and rejection that characterizes the true artist," and praised his slides as "technically perfect."[28] Subsequently, the society's newsletter reported that Post excelled at making seascape slides and frequently contributed to the set the club circulated through the American Lantern Slide Interchange.

ASSESSING OTHER PHOTOGRAPHERS

IN LATE 1894, POST REVIEWED THE photographic section of the 23rd Regiment Fair for *American Amateur Photographer*, probably at the request of his friend Stieglitz, who was the magazine's editor. While Post would later write a few articles about his own photography, this exhibition review is the only instance in print where he expressed his opinion about other people's work.

The fair, held in November at the 23rd Regiment Armory building in Brooklyn, included nearly one thousand prints and almost four hundred lantern slides. Although Post's own images were in the show and were awarded a certificate, he refrained from mentioning that fact in the review.

Post began his critique by referring to the photographic section as a "side show." Apparently this was the only time the fair ever displayed photographs, and Post was openly dismissive of the selection, finding very little work of merit and considering the overall presentation undignified. He also objected to the number of awards given and criticized the organizers for requiring the judges to present the full allotment of medals and certificates. "This is distinctly an error," he wrote, "as it puts a premium on bad work." [29]

While at least 140 photographers had work in the show, Post thought only a handful of them deserved attention: "Among the numerous exhibitors, the writer has selected less than a dozen whose work approaches the dignity of being called pictures." [30] Of this group, only a few remain known today, the most important being Alfred Stieglitz. Stieglitz had three carbon enlargements in the exhibition, which Post praised highly: "They are all enlarged from hand camera shots, are beautiful in treatment, grand in technique and in artistic qualities, and leave nothing to criticize." [31] He went on to say that *Winter, Fifth Avenue*, which won a medal, was the best of the three.

Post also lauded the well-known pictures of Rudolf Eickemeyer, Jr., "which have been so often criticized that the writer will only add that they are of the highest order." [32] Eickemeyer was a leading landscape photographer, already making the kind of images Post would soon attempt. Among them was *Sweet Home* (fig. 6),

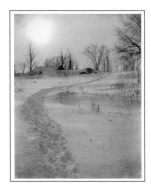

Fig. 6. Rudolf Eickemeyer, Jr., *Sweet Home*, 1894, platinum print, private collection

which Post singled out in his review and which later provided inspiration for his own work.

Most of the other photographers Post complimented are little known today but fell into a few clear categories. Some of them were members of the Society of Amateur Photographers, such as Charles I. Berg. Others, like E. Lee Ferguson, produced landscapes, a genre Post would soon explore himself. He also took notice of work by women photographers, a significant class of creative amateurs well represented in the exhibition. In particular, Post recognized Emilie V. Clarkson, for her set of lantern slides; Emma J. Fitz, whose genre scenes he thought perhaps the best in the show; and Emma D. Sewell, who received a medal for an image featuring snow, a subject Post would later specialize in.

Not surprisingly, Post praised photographs in the exhibition that reflected his own developing aesthetic. He was especially intrigued with landscapes, the genre that would soon claim most of his attention. And he made a point of discussing lantern slides, the form in which he was then working. When he began collecting photographs a few years later, he acquired many by Stieglitz and Eickemeyer, the two whose pictures he admired most in the show.

PROLIFIC EXHIBITING

POST EXHIBITED HIS WORK FROM the late 1880s, a few years after he began photographing, until 1921, the year he died. Between 1893 and 1910 he had pictures in at least one exhibition annually. He was most active in 1894, 1895, and 1896, when he participated in at least twelve exhibitions each year. And over those three years, his images were reproduced in the photographic press more than at any other time.

During the mid-1890s, advanced amateur photographers exhibited their work at a number of venues. In this country, they showed in national exhibitions of significance and at camera clubs, both as members and as guests. In Europe, they submitted their pictures to a richer host of sites, including international art expositions, photographic salons, and camera-club shows.

In 1894, Post showed in thirteen exhibitions, only three of which were in the United States. The 23rd Regiment Fair show, which he reviewed for *American Amateur Photographer*, included his early important picture *The Critic* (fig. 7). The image features Stieglitz sitting in front of a painting and acknowledges his critical faculties in the visual arts. Post's work was also seen in a show at the Camera Club of Hartford that had only nine exhibitors, all of them nonmembers. The quality of the work and the stature of the photogra-

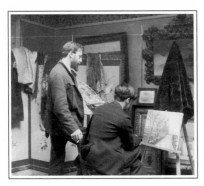

Fig. 7. William B. Post, *The Critic*, 1894,
platinum print, collection of Mary Weston

phers prompted the *Photographic Times* to call that show "the finest exhibition of photos ever given by the club."[33] In New York, Post's photographs appeared in the last Joint Exhibition, where they received praise from Stieglitz: "His pictures show conscientious study and serious thought. Mr. Post is undoubtedly one of the very few of the progressive workers we have here in the United States."[34]

The same year, Post's images were accepted at numerous exhibitions in Europe, including some half-dozen photography shows in England and several international art expositions in Italy, Germany, and the Netherlands. In July, Stieglitz, who was traveling in Europe, wrote to compliment Post on work he was showing in Milan, at an exhibition with photographs by only three other Americans.[35]

In 1895, Post exhibited primarily at shows sponsored by domestic and foreign camera clubs. He participated in the New York Camera Club's annual members' exhibition, which Joseph Obermeyer, a member of the rival Society of Amateur

Photographers of New York, reviewed. While disappointed with much of it, Obermeyer praised Post: "Far and away the best exhibit on the walls was that of Mr. W. B. Post, one of the few workers who have maintained the standard of American photography abroad. Mr. Post's range is a large one, embracing genre and figure work, summer and winter landscape and marines, but he unquestionably excels in landscape and marine."[36] Post also had pictures in the National Amateur Photographic Exhibition, organized by the National Camera Club in Washington, D.C. Outside of the United States, he showed with such organizations as the Toronto Camera Club, the Royal Photographic Society (London), the Photography Club of Paris, the Photographic Circle of Brussels, and the Photographic Society of India (Calcutta).

In 1896, despite an unspecified illness, Post exhibited more than at any other time in his career, having works in no less than sixteen shows in nine countries. In the annual members' exhibition of the Society of Amateur Photographers of New York, he provided twenty of the show's fifty pictures, thereby dominating it. The club honored him further by including a photogravure of one of his landscapes in the catalogue, the only other illustration being by Stieglitz.

Post successfully sent work to England, Scotland, Wales, France, Germany, Holland, Belgium, and India. Throughout that year, his pictures were so prevalent abroad that the *Photographic Times* included him in its article "American Exhibitors in Europe,"

which featured only eight photographers.[37] Prominent European organizers like Ernst Juhl in Hamburg solicited Post's work for their exhibitions and always asked for permission to illustrate his pictures in their publications.

During the three-year period from 1894 to 1896, Post saw his images reproduced more than ever before. At least twenty-two reproductions of his pictures appeared, covering the full range of his output: landscapes, seascapes, figure studies, and images of Japan. Printed as halftones or photogravures, his works were illustrated in the monthlies *American Amateur Photographer* and *Photographic Times*, as well as in the *American Annual of Photography* and the English annual *Photograms of the Year*.

NATURALISTIC PHOTOGRAPHY

THROUGHOUT MOST OF THE 1890s, Post practiced the "naturalistic" style of photography. Usually working outdoors, he photographed figures in the landscape or nature alone. His subjects included women gardening, farmers harvesting, grazing sheep, and fields, lakes, and forests in every season. In these images, Post celebrated and idealized rural living, mother nature, and the simple life.

Peter Henry Emerson, an Englishman who produced outstanding examples of naturalistic photography, spearheaded the movement. In 1889, Emerson published his book *Naturalistic Photography for the Students of the Art*, naming the style and making a case for photography as art. He advocated nature as subject and inspiration, simple compositions, and differential focusing. He also advised photographers to make images that read as one harmonious whole, by choosing a single point of interest and downplaying all surrounding detail. To that end, he introduced the idea of sharply rendering only the primary subject and making everything else slightly out of focus, an approach he thought mimicked normal human vision.

Believing nature to be the true fountainhead of all creative expression, Emerson particularly admired the romantic realism of the French painter Jean-François Millet, even quoting Millet in his book: "We should accustom ourselves to receive from nature all our impressions, whatever they may be, and whatever temperament we may have. We should be saturated and impregnated with her."[38]

Although two years after issuing his book Emerson retracted his statement about photography being an art, his approach to photography had wide influence. During the 1890s, naturalistic photography became a major movement in both

the United States and England. It thrived in Philadelphia, where a whole school of naturalists formed, including John G. Bullock and Henry Troth. Stieglitz practiced the style as well, especially in images he made in Europe. And Post also embraced naturalistic tenets, becoming a disciple of Emerson's by 1894.

Post could have been exposed to Emerson's ideas and images through many sources. He might have read Emerson's book in 1889, when it was originally published in England, or a year later when the American edition came out. Alternatively, he could have read a digest of it in 1893 in the *Photographic Times*. By then, Emerson had published seven books and portfolios of his work, producing hundreds of prints for distribution to fellow photographers. His images had also been reproduced in several American photographic magazines. Undoubtedly, Emerson's most influential picture was his contemplative *Gathering Water Lilies* (fig. 8), which was first published in 1887.

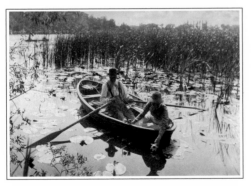

Fig. 8. Peter Henry Emerson, *Gathering Water Lilies*, 1886, platinum print, The Minneapolis Institute of Arts

Eight years later, Post made his own rendition of Emerson's signature piece, creating *Summer Days* (plate 1) in 1895. Despite its derivative nature, this is Post's finest example of naturalistic photography. The subject, a woman in a boat, is at one with nature as she floats serenely among lily pads on the placid water. The flowers she is gathering will be a reminder of this tranquil interlude. Full sunlight bathes the scene, providing both a well-defined reflection in the foreground and an optimistic atmosphere throughout.

Post was not alone in drawing inspiration from Emerson's 1886 image. Other accomplished amateurs, like Alexander Keighley and Rudolf Eickemeyer, Jr., also made versions of *Gathering Water Lilies*, suggesting that to do so was something of a rite of passage for many naturalistic photographers.

Post's *Summer Days* was frequently reproduced and exhibited, proving its acceptance as an independently successful picture. It first appeared in July 1895 as a frontispiece in the *Photographic Times*, which printed it in green ink to reinforce its natural subject matter. To produce the work's rich tonalities, the magazine used the high-quality photogravure process and allowed the engravers to etch faint plant forms just outside the image area, giving the print a distinctive handcrafted quality.[39] Shortly thereafter, halftones of Post's image and a variant were printed in periodicals in England and Germany, making the picture available to an international audience.

Post may have initially exhibited *Summer Days* at the 1895 National

Amateur Photographic Exhibition in Washington, D.C., where it received a gold medal. It was displayed in several other shows as well, including an 1898 exhibition at the National Academy of Design in New York, where it was described as "a picture remarkable for its clearness and crispness."[40] In all these instances, Post exhibited the image as a platinum print, not as a lantern slide. In the mid-1890s, he and many other photographers began to prefer prints, which could be hung on walls, over transparencies, which required projection of some kind. And they universally used platinum paper because it yielded velvety tones of great subtlety. Emerson highly recommended platinum printing for the best naturalistic effects, and Stieglitz, too, advocated the medium, calling it the "prince of all processes."[41] In fact, platinum printing dominated artistic photography until World War I, when it became prohibitively expensive and companies stopped making the paper.

THE NEW YORK CAMERA CLUB AND PICTORIALISM

BY THE MID-1890s, BOTH THE New York Camera Club and the Society of Amateur Photographers of New York were struggling. The camera club had a large membership and sound finances but lacked talent. The society had skillful photographers but needed money and more members. Wisely, the two groups decided to consolidate, which they did in May 1896. The new organization started with 272 members, took over the society's location on West 38th Street, and called itself The Camera Club, New York (soon known as the Camera Club of New York). Post, an original member of both clubs, became a founding trustee and one of only nine initial life members.

The Camera Club of New York quickly became the leading group of amateur photographers in the United States, a dominance it held for the next half-dozen years. Its membership boasted the country's most advanced workers, including such New Yorkers as Stieglitz and Eickemeyer, and nonresidents like Clarence H. White of Ohio. The club presented an unprecedented series of one-person exhibitions and, under the editorship of Stieglitz, published the quarterly *Camera Notes*, by far this country's most lavish and artistic photographic journal. Through its meetings, members, exhibitions, and periodical, the Camera Club of New York became the major American force in the new movement known as "pictorialism."

For its adherents, pictorial photography meant artistic photography.

Stieglitz, Post, and others used the term when discussing their works to lessen the threat to established artists in other media. Despite this diplomatic approach, the pictorialists were intent on making *pictures* with their cameras, by which they meant images of aesthetic value. The word "pictorial" implied an association with a class of pictures that was largely made up of fine paintings, prints, and drawings. Aspiring pictorialists who read *Camera Notes* were encouraged to study the work of Rembrandt and other old masters to learn about artistic posing, lighting, and composition.

Pictorialism took cues from naturalistic photography and was characterized by accessible subject matter, soft-focus effects, and simplified compositions. Pictorialists used a relatively limited number of subjects that were easily appreciated by the public. Avoiding anything topical, political, or controversial, they concentrated on figure studies, landscapes, and genre scenes. To distinguish their images from ordinary photographs, they purged their pictures of all detail and extraneous elements. By simplifying the scene and softening the focus, pictorialists produced mysterious, evocative images, which they considered extremely artistic.

Pictorialists worked with a narrow range of themes, in part because they wished to downplay the importance of subject matter. They knew that photography was subject-laden because it was fully dependent on the real world for its imagery. But they also knew that pure transcriptions of everyday life did not make art. Consequently, they preferred subjects that did not call much attention to themselves, insisting instead that the presentation of the subject—not the subject itself—was what mattered.

In addition to downplaying subject matter, the pictorialists chose to suppress detail. Soft-focus effects were the most identifiable aspect of their style. By softening the image, pictorialists distinguished their works from ordinary, sharply focused photographs and imparted an emotional quality. Seeking to communicate their personal feelings and responses through their pictures, they created photographs that were low in tone and high in suggestion.

For visual effects, pictorial photography also relied on compositional simplicity. While good composition depended on subject placement, line, form, light, and shade, the pictorialists quickly learned that the less they included, the better their pictures looked. Accordingly, they eliminated the inessential, strove for simplicity, and skillfully emptied their pictures of unnecessary detail in order to suffuse them with meaning.

MOVING TO MAINE

ON THE MORNING OF JUNE 3, 1897, Post was frantically summoned to the floor of the New York Stock Exchange, where his sixty-three-year-old father lay seriously ill. Samuel L. Post, Jr., never regained consciousness and died within minutes. He had been a stockbroker his entire adult life and a prominent member of the exchange for more than thirty years. The *New York Times*, which devoted nearly a full column to his obituary, reported that he was one of the exchange's best-known and most successful members, who had amassed an "ample fortune" by the time of his death.[42]

This tragic event significantly altered William Post's future. Upon his father's death, he inherited money and property, a circumstance that led him to make major changes in his life. In December 1897, Post sold his membership in the New York Stock Exchange and quit his job, decisions that strongly suggest he had worked as a broker largely to please his father. Soon afterward, he decided to leave New York. His name disappears from the Manhattan directory in 1898, the year he moved to Fryeburg, Maine.

Located about forty-five miles west of Portland, near the New Hampshire border, the village of Fryeburg had about five hundred residents and was as picturesque a spot as any in New England. A historian who wrote about the town observed: "By no means a trivial possession of Fryeburg is the scenery. In the foothills of the White Mountains, the town is yet far enough away from the higher peaks to soften the outlines and give the whole landscape a beauty impossible in nearer views."[43]

Samuel Post had bought land there in 1880, and by the time of his death owned a comfortable house on Fryeburg's main street. At the age of forty and still single, William Post inherited that house and enough money to not have to work. Having escaped the concerns of city life, he began writing to Stieglitz from Maine on stationery with the letterhead *Sans Souci* ("without worry"), the name of his new residence. But more important, Post began spending considerable time in his rural surroundings, absorbing the landscape's quiet atmosphere and photographing it in all its guises.

WINTER PHOTOGRAPHY

PHOTOGRAPHERS AGREED THAT winter was the most difficult time of year to make landscapes. Besides being physically uncomfortable, the cold weather adversely affected their equipment. Consequently, most pictorialists took few outdoor pictures during the winter, reserving that season for indoor activities like developing negatives and making prints.

Nonetheless, many publications advocated winter work and discussed its artistic, technical, and psychological aspects. Photographers wrote about working in such winter locations as New Hampshire's White Mountains and about particular subjects, like ice and snow-covered trees. Sadakichi Hartmann, an art and photography critic, observed that winter was an especially appropriate season for creative photographers because then nature was devoid of vivid colors. In an article illustrated with two of Post's winter scenes, Hartmann wrote, "Monochrome, the subtle differentiation of light and dark, is the photographer's medium of expression, and the winter offers him proper landscape themes more readily than any other time of year."[44]

Pictorialists all seemed to agree that the best time of day to photograph was either early or late, when the sun was low and shadows were long. As the accomplished winter photographer William S. Davis noted, "Shadows play a most important part in snow pictures, for snow is not properly represented by pure white in the print."[45] And taking the advice of paper manufacturers, most pictorialists finished their winter prints with cold toners, so the hues matched the color and chilliness of the imagery.

After moving to Maine, Post made winter one of his primary subjects and an area of photographic expertise. His snow scenes, which were widely seen and praised during his lifetime, are what he remains best known for today. These quiet, contemplative winter compositions are refined and understated and often show Japanese influence, as in their use of shades of light and dark (*nōtan*).

Post expressed his appreciation of winter as early as 1891, while traveling in California. Having experienced the state's "perpetual summer," he wrote in his diary: "I prefer our Eastern winter. I like the snow and the consequent winter amusements and I think most anyone has better health and is more rugged in a bracing air."[46] Post was making winter photographs by 1895, when he exhibited some in New York, London, and India. The next year, he won second place in a competition for winter pictures held by the *Photographic Times*. The magazine's editor conceded that snow was a difficult subject for photographers but felt it offered them good opportunities because painters and printmakers rarely made

winter scenes. In 1897, Post's winter images received significant exposure, being reproduced in both *Wiener Photographische Blätter*, a leading German periodical, and *Sunlight and Shadow*, an important book for advanced amateur and professional photographers edited by W. I. Lincoln Adams.

Although Post had made successful snow pictures before he moved to Maine, he did his best winter work after he relocated there. In 1899, just a year after arriving in Fryeburg, he created his signature piece: *Intervale, Winter* (plate 4). Photographing an intervale (a low-lying tract of land along a river) just outside of town, Post employed a radical composition and subtle tonalities to virtuoso effect. He boldly placed the horizon line high in the frame, filling the foreground and middle distance with a large expanse of flat and empty open space. By silhouetting the line of trees along the horizon and the spray of grass in the foreground, he equalized their mass and emphasized their decorative quality. As a result, the picture contains few values and scant subject matter but abounds in suggestion and symbolism. It reveals Post skillfully evoking nature rather than documenting a particular place.

Intervale, Winter received wide acclaim, both at exhibitions and in periodicals. Post showed prints of it in New York, Philadelphia, Chicago, Portland (Oregon), and Glasgow. In 1900, he included it in a one-person exhibition at the Camera Club of New York, where it was admired by Sadakichi Hartmann: "I know of

nothing more exquisite in recent landscape photography than that picture where a straight line at the horizon separates the stretch of snow from the depleted vegetation in the distance and the sky. Its simplicity is astonishing. It almost seems like an insult to Dame Nature that she can be expressed in terms of such simplicity, but it should be accounted rather as a virtue than a shortcoming that the artist can see nature so simply and in such a sound attitude of mind."[47] The image was later reproduced as a photogravure in *Camera Notes*, in the Chicago periodical *Photo Beacon*, and as a frontispiece in *American Amateur Photographer*.

Post made many other pictures of Fryeburg and its snowy environs, where the winters were long and cold. He sometimes included farmhouses and barns, but generally preferred landscapes devoid of buildings and people. He often pared down his subject matter to its essence—ground, trees, and sky. His affinity for Japanese aesthetics appears in images of nearly abstract simplicity and in elongated vertical formats that counter the landscape's strong horizontality. In one picture (plate 9), for instance, he pushed the horizon line even higher than in *Intervale, Winter*, so that the foreground takes up fully nine-tenths of the frame. And in another (plate 10), he rendered all the snow in a single continuous tone, relieved by only one shallow footprint in the lower corner and his signature, each serving as a decorative flourish.

In 1910, Post wrote a short article on snow photography that explained his motivation and technique. "It occurs to me that I have chosen photography of the snow as my favorite subject for landscape work because of the truer rendering of tones and color values," he said. "It is much more satisfactory, and to me a great deal easier, to have a minimum of reds and greens on the ground glass." [48] In other words, Post agreed with Hartmann's observation that photographs were easier to visualize during winter because nature was largely monochromatic at that time of year. Post also indicated that he used a slow lens and 8-by-10-inch orthochromatic plates. He concluded by saying winter work is "as full of trouble and requires as much patience as any other in photography; but when all goes well the results are truer and more satisfactory than most other landscape work." [49]

PHOTOGRAPHING WATER LILIES

POST PHOTOGRAPHED WATER lilies as passionately as he did snow, making pictures that rival his best winter scenes. And water lilies were the only subject other than snow that he wrote about in the photographic press. An article published in 1914 begins: "Working with broad-leaved water-plants yields much to the picture lover and to one to whom the beauties of nature constantly unfold in new revelation. In my locality the water-lily takes precedence; indeed, it is the only water-plant that lends itself to reproduction in monochrome." [50] The human interest provided by the woman in his early water-lily image, *Summer Days*, became unnecessary, and Post's later photographs picture water lilies alone.

Most often, Post photographed water lilies at a small lake called Lovewell's Pond, a few miles east of Fryeburg.

After riding there in his horse-drawn buggy, he would put on waders and lug his 8-by-10-inch camera out into the water. He took long exposures at a small aperture setting and preferred working in the morning and on windless days, when the water and flowers remained still. Usually he lowered his tripod within a foot or two of the water, getting physically close to the subject. "The immediate foreground will show clearly," he wrote, "and the flowers and leaves will take the glint of sunlight, the middle-planes will soften, and the rising mist will impart to the distant trees and mountains the proper atmospheric value, and also give the sky a tonal value." [51] He offered little technical advice in the article, concentrating on his experiences in the countryside and making his admiration for nature clear.

By purposely tilting his camera down, Post excluded the horizon line from many of his water-lily images, making them as abstract as his snow pictures and equally removed from reality. Like his winter landscapes, Post's water lilies are understated decorative schemes rendered in limited and subtle tonalities. For the lilies, he used an elongated horizontal, as well as a vertical, format. The horizontal pictures tend to feature a few flowers nestled together, while the vertical ones often show more flowers strung out over a distance.

In reviewing Post's one-person exhibition in 1900, Sadakichi Hartmann wrote glowingly about the photographer's water lilies, thinking them as strong visually as his pictures of snow. "Delightful also are his studies of water lilies. Here again we meet the pearly atmospheric quality which is so rare in photography. He strives to express the exquisite delicacy of still water, the shapely growths of reeds in the distance and the shimmering surface of large leaved water plants. These pictures show an effective combination of the elements of natural poetry with decorative treatment."[52] Hartmann could have written similar comments about Claude Monet's paintings of water lilies, although Monet's work is large and colorful whereas Post's is intimate and monochromatic. While both artists treated the same theme at about the same time, they probably had no influence on each other.

SLOWED PHOTOGRAPHIC ACTIVITY

DESPITE HIS NEW ENTHUSIASM for photographing snow and water lilies, Post decreased his photographic activities during the last few years of the nineteenth century. He photographed less, possibly because of poor health, and exhibited less, probably because of his more isolated location. However, when he did show, his work still received high praise. At the same time, he remained involved with the Camera Club of New York, as a nonresident member, and deepened his relationship with Stieglitz through regular correspondence.

In 1898, Post had work in only five exhibitions, most of them in New York City. Among them were shows organized by the Eastman Kodak Company and the American Institute, both presented at the National Academy of Design. Post also showed a winter landscape in the first annual members' print exhibition at the Camera Club of New York.

Although living in Maine, Post maintained his interest in the camera club, contributing both photographs and money during the late 1890s. In addition to exhibiting in members' shows, he gave

six of his best pictures, tastefully framed, to the club's new permanent collection. In 1898, Post was one of the largest donors to a fund that allowed the club to move into spacious, better-outfitted quarters on West 29th Street. So impressive were those facilities that the novelist Theodore Dreiser described them as a "$10,000 photographic plant" that took up an entire floor of a building. [53]

In 1898 and 1899, the Camera Club of New York featured one of Post's images in two of its important publications. *A Pasadena Landscape* (see p. 15, fig. 2) was reproduced as a photogravure in both *Camera Notes* and the portfolio *American Pictorial Photography, Series I*. For pictorial photographers, inclusion in these publications was a great honor. *Camera Notes*, the country's leading photographic journal, dubbed Post "one of the most prominent of American photographers." [54] *American Pictorial Photography* had an even more exclusive selection of images, which consisted of eighteen plates in a deluxe portfolio. The camera club published the portfolio in a limited edition of 150 copies to meet the requests *Camera Notes* received for individual gravures, and Stieglitz, as chairman of the publication committee, signed each one.

Stieglitz and Post had a close relationship during the late 1890s. Between May and December 1898 Post wrote to Stieglitz at least ten times, on a variety of topics. He casually began one letter by asking, "What's new?" and frequently

sent his regards to Stieglitz's wife. In September, he congratulated Stieglitz on the birth of his daughter, Kitty. "Kiss the baby for me," Post instructed, "and don't bring her up as an amateur photographer, one in a family is enough." [55] He wrote about the Maine weather, his health, and his finances. He even boasted to Stieglitz that he had made five thousand dollars, a large sum at the time, on a particular stock in just two weeks. And he also discussed exhibiting, collecting photographs, and his own artistic successes. Late in the year, he exclaimed, "Have done two things I think the best I ever did," without specifying the subjects.

About nine months later, however, Post had shocking news for his friend in New York. In a letter dated September 3, 1899, he told Stieglitz he had been living with the fear of death by blood poisoning and had had twelve abscesses surgically removed. And while he insisted his prospects for recovery were good, he also said he would "always be a cripple" and that he was laying his camera "aside forever."

Thankfully, Post was able to resume photography a few years later. In the meantime, he exhibited earlier work and built a significant collection of photographs by other pictorialists. He even presented a one-person show of his images at the Camera Club of New York in 1900, a significant feat for a man who thought his life as a photographer had come to an end.

COLLECTING PHOTOGRAPHS

AT THE TURN OF THE CENTURY, very few individuals collected photographs, simply because most people were not convinced they were art. Some enlightened art collectors occasionally paid money for fine photographic prints, but the few serious collectors of photographs were nearly all photographers themselves. They understood photography better and appreciated it more deeply.

Early in 1899, *Camera Notes* reported that Post had joined this small cadre of collectors. "Within the last year or so, Mr. W. B. Post, himself a prominent photographer known the world over, has been quietly purchasing many splendid examples of pictorial photographs with which to form the nucleus of what promises to be a unique collection. Mr. Post is a connoisseur *par excellence*, and has determined to procure only the very best, willingly paying a liberal price for such work. It is his aim to own the masterpieces of the leading photographers." The article indicated that Post had acquired work by Stieglitz and Gertrude Käsebier and concluded, "He frames his pictures with exquisite taste, and it is only a question of time when the Post collection will be the most notable in the country."[56]

Post sought Stieglitz's help in creating his collection, asking him to procure specific pieces for him and taking his recommendations as well. Stieglitz attended more exhibitions and saw more work than Post did and was an acknowledged tastemaker in photography. In 1898, Post asked Stieglitz to buy prints for him from the American Institute exhibition at the National Academy of Design, requesting the best images by F. Holland Day, Frances Benjamin Johnston, and Hinsdale Smith, who had won the show's gold medal for landscapes. He also authorized Stieglitz to make his own selection of $200 worth of prints in the 1898 Philadelphia Photographic Salon, then the most advanced exhibition of its kind in this country. Sales at that exhibition came to $378, so Post was responsible for more than half the purchases.

At the time, the average price for a pictorial photograph was $10 to $20, although a Käsebier print sold at the next year's Philadelphia salon for the record price of $100. As the *Camera Notes*

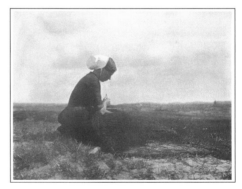

Fig. 9. Alfred Stieglitz, *Mending Nets*, 1894, photogravure, published in *Camera Notes*, January 1899

article indicated, Post was willing to spend large sums, and in 1898 he sent a check for $50 to Stieglitz for a carbon print of *Scurrying Home*—possibly the most he ever paid for a photograph. The same sum could have bought a top-of-the-line upright piano from Sears, Roebuck and Company. Post's letters also reveal that he paid $30 for *Mending Nets* (fig. 9), an image he declared soon afterward to be his favorite by Stieglitz.

Post only acquired the best prints of what he considered key images, a task made easier because he bought directly from photographers or out of contemporary exhibitions. He insisted, for instance, on a signed original print of Stieglitz's *Scurrying Home*, writing, "You are way off when you say I will have to get along with a gravure." [57] He was well aware of the possible quality differences between prints made from the same negative and was particular about what he bought. "I have the nucleus of a fine collection," he asserted to Stieglitz, "and can afford to be very careful as to future additions." [58]

Post collected Stieglitz's work in depth, believing in late 1898 that he had more of it than anyone other than the photographer himself. Stieglitz regarded Post and his collection so highly that he, uncharacteristically, even gave him some pictures. This generosity prompted Post to write Stieglitz, "You will of course know that I do not place a commercial value on your work, and that these prints that you have given me (without consideration of which has the most artistic

PRIVATE SALE
Fryeburg, Me.
Wednesday, August 22

The following articles will be on sale between the hours of 10 a. m. and 5 p. m.,

At the Home of Mrs. W. B. Post

Oriental Rugs, Separate Pieces of Furniture Several Sets of Fine Books, Dishes of Valuable Ware and a few Antiques.

A Rare Collection of Photographs

the work of W. B. Post, many of which are most suitably framed. Also photographs by the well known artists, Steiglitz, Frazer, Mrs. Casebier, Hosley, Hinton and others.

Fig. 10. Handbill for sale of Post's possessions, August 22, 1923, collection of Mary Weston

value) are held in higher esteem than those acquired by purchase." [59]

Unfortunately, neither Post's collection nor even an inventory of it exists today. In 1923, a few years after Post's death, his wife held a private sale, offering the collection, along with antiques, fine books, household items, and many of Post's own photographs. The handbill for the event (fig. 10) offered "A Rare Collection of Photographs" and mentioned the names of four photographers (all misspelled). However, from Post's letters and other sources, [60] a fuller list of photographers whose work Post owned can be compiled: Charles I. Berg, Shapoor N. Bhedwar, William A. Cadby, E. P. Cembrano, Emilie V. Clarkson, F. Holland Day, Robert Demachy, Mary Devens, Rudolf Eickemeyer, Jr., Frank Eugene, Emma J.

Farnsworth, E. Lee Ferguson, William A. Fraser, A. Horsley Hinton, Frederick Hollyer, Frances Benjamin Johnston, Gertrude Käsebier, Bernard Lintott, William D. Murphy, Ralph W. Robinson, Hinsdale Smith, Alfred Stieglitz, Mathilde Weil, and Clarence H. White. The only time Post quantified his collection was in late 1898 when he wrote Stieglitz saying he had sixty-two photographs framed and hanging in his bedroom, a number that most likely increased. In 1925, two years after her sale, Mrs. Post gave a framed print of Stieglitz's *Winter, Fifth Avenue* to the Museum of the City of New York in memory of her husband.

Though certainly significant, Post's collection was not unique. Stieglitz himself was building a collection, which eventually grew to nearly six hundred photographs and is the only one of its kind to survive.[61] F. Holland Day, of Boston, created a small, refined collection of pictorial photographs but lost much of it in a studio fire. Little known today but noticed at the time were the holdings of George Timmins, a Syracuse businessman and amateur photographer, who owned more than 275 prints by 1896, including 3 by Post. Sadly, Timmins's collection, like Post's, was dispersed after his death by his widow.[62]

ONE-PERSON AND OTHER EXHIBITIONS

AROUND THE TURN OF THE century, exhibition opportunities for photographers in the United States expanded dramatically, through established art museums and camera clubs alike. Although not actively photographing at the time, Post understood the importance of prolonged visibility and continued exhibiting his work at various venues. In 1897, E. Lee Ferguson asserted in *Camera Notes*: "The value of exhibitions in all sorts of art work has long been recognized. Rightly managed, an exhibition encourages the advanced workers, points the way for beginners, and elevates the public taste."[63]

In particular, Post exhibited in two major American photographic salons. In 1900, two of his pictures were accepted for the third Philadelphia Photographic Salon by a jury that included Stieglitz, Gertrude Käsebier, and Clarence H. White. This short-lived series of salons, at the Pennsylvania Academy of Fine Arts, maintained the highest artistic standards in the country, stating in its catalogues: "The purpose of the Salon is to exhibit that class of work only in which there is distinct evidence of individual artistic feeling and execution, the pictures to be rigidly selected by a competent jury."[64]

Joseph T. Keiley, a photographer who extensively reviewed the salons for *Camera Notes*, was happy to see Post's pictures in the 1900 presentation and noted that the American work, in general, was far superior to that in the first two salons. Post, appropriately enough, showed one snow scene and one image of water lilies, which the *Photographic Times* called a "poem of peace." [65]

In 1901, Post had two pictures in the second Chicago Photographic Salon, presented at the Art Institute of Chicago. One of them, his now-famous *Intervale, Winter*, was reproduced as a full page in the salon's catalogue, an honor bestowed on only 16 of the 130 pictures in the show.

Most important, Post had a one-person exhibition of his photographs at the Camera Club of New York in 1900, the most significant show of his entire career. Held December 1 through 10, it was part of an eye-opening series the club had started a few years earlier. Among those who had already shown were Stieglitz, Day, Käsebier, and White, prominent photographers that Post was comfortable being associated with. During the run of these exhibitions, Sadakichi Hartmann offered the following observation: "'One-man shows' such as the Camera Club of New York has arranged during the last few years, have undoubtedly done most towards giving us a true idea of the possibilities of the camera as a medium of artistic expression. We could at once grasp each exhibitor's individuality, his special aims and technical characteristics, and study the graded development of his art from his earlier to his most recent works." [66]

No catalogue of Post's one-man show survives, but Hartmann wrote a detailed review for *Camera Notes*. The show comprised at least fifty-one photographs, including early portraits and figure studies that Hartmann found boring. However, he was very enthusiastic about Post's mature landscape work. "One does not know what Mr. Post is capable of before one studies his snow landscapes and water lily ponds. They alone reveal him; although neither faultless nor complete in every detail, they at all events show him an artist to the core. There we have a boundless wealth of loveliness before us." [67] Hartmann said he "might term him the poet of snow and water lilies," but hoped Post would not limit himself to those subjects. "His talent lends itself curiously well to the realization of open air effects. He understands the delicacy and luminosity of daylight, and the gentle gradations of color that result from the aerial varieties of our climate." [68] Hartmann, who wrote extensively on all the arts, remarked that Post was the one photographer he wished could also paint. Paying Post an immense compliment, Hartmann made it clear that he considered him first and foremost an artist.

RESUMING PHOTOGRAPHY

IN LATE 1899, A YEAR BEFORE HIS one-person exhibition, Post sent Stieglitz a letter from his home in Maine. "You have got a cinch," he wrote, "and I sometimes wish I had a wife and baby. I am a very lonely man."[69] In that letter he also spoke about his relatives, mentioning his sister who had a family of her own and an aunt who had recently died.

Two years later, Post fulfilled part of his dream. On October 1, 1901, he married Mary Webster Weston (1866–1957), a thirty-five-year-old woman from a prominent Fryeburg family. Subsequent letters to Stieglitz indicate they had a happy marriage. But they never had children.

A few months after his wedding, Post wrote Stieglitz again with equally important news. He had resumed photographing. He did not explain why, other than to say, "There have been good chances for winter work this year."[70] His health must have improved, and his wife may have encouraged him. A month later, in February 1902, he sent Stieglitz a dozen new prints, asking him to consider them for publication in *Camera Notes*. Although that did not happen, Post was back, working again and pursuing nature as his primary theme.

For the rest of his life, Post would photograph landscapes exclusively, disparaging other subjects. After seeing a nude by Frank Eugene, for instance, he wrote Stieglitz that the genre was "dangerous" and that Eugene's picture was un-

successful.[71] Post loved photographing outdoors and took the view "that most everyone is more or less a lover of flowers and plants, and to copy them amid their native environments is a privilege and pleasure, alike to the painter and the camera worker."[72]

Dedicated to portraying nature's subtleties, Post rose at daylight for two weeks to capture fog the way he perceived it. He knew trees so well that he criticized Anne Brigman, a fellow pictorialist, for incorrectly identifying one of her subjects as a pine. He also claimed to prefer landscapes that were sun-drenched and optimistic rather than dark and dreary. "The fact remains," he lectured Stieglitz, "that there are many who still love nature in her cheerful and true moods."[73]

Taking Sadakichi Hartmann's advice, Post expanded his range of landscape themes beyond snow scenes and water lilies. In the spring, he was particularly drawn to blossoming apple trees and pictured them in glistening groves. In the fall, to capture the harvest mood, he wandered into fields of pumpkins and haystacks.

Post rarely created images that showed large expanses of the terrain, preferring instead to look at only small sections at a time. He believed that nature photographers should focus on carefully selected bits rather than the whole scene in front of them. Sometimes he printed details of

trees and grass as small as 2¼ by 4⅛ inches, producing pictures that are difficult to orient right side up. In a similar vein, he sometimes cropped his negatives so severely that he made prints having proportions of one to four. And some of his flower-garden images are composed symmetrically, in order to suggest the garden's formal layout.

Essentially, Post was using his camera to make lyric poems about nature. His deep love of the natural world contained a strong spiritual element; in a sense, he worshiped nature. He agreed with the art critic Charles H. Caffin, who said in his book *Photography as a Fine Art* (1901) that "landscape art is the real religious art of the present age." With regard to photography, Post could certainly be considered a high priest of that art.

THE PHOTO-SECESSION

POST RESUMED WORKING JUST IN time to join a new group of photographers that Stieglitz organized in 1902. Named with a nod to European artists who had seceded from conservative arts organizations, the Photo-Secession was an elite group of pictorialists who would dominate American artistic photography for the rest of the decade. Its members produced highly refined images and carefully crafted prints that set the standard for advanced pictorial photography. Through its exhibitions and lavish quarterly *Camera Work*, the Photo-Secession, handpicked by Stieglitz and under his guidance, proved that photography is indeed a fine art.

The Photo-Secession made its debut in March 1902 in an exhibition Stieglitz created for the National Arts Club in New York. Simply titled "American Pictorial Photography Arranged by 'The Photo-Secession,'" the show featured more than 160 pictures by thirty-two individuals, including 2 by Post. Gertrude Käsebier, Edward Steichen, Clarence H. White, and Stieglitz exhibited the most works and would remain the group's most prominent members. The exhibition set an attendance record at the arts club and was favorably reviewed by many New York newspapers and by national magazines such as *Cosmopolitan*. The *New York Sun* raved, "This is not only the best exhibition ever held at the Arts Club, but the best of its kind that has yet been seen in New York."[74]

At the time of the inaugural exhibition, the Photo-Secession existed only in Stieglitz's mind, for no members had as yet joined, no meetings had been held, and no officers elected. It was not until nine months later, in December, that Stieglitz issued the group's first newsletter, which listed thirteen "Council" members

and stated the Photo-Secession's objective: "To advance photography as applied to pictorial expression; to draw together those Americans practicing or otherwise interested in the art; and to hold from time to time, at varying places, exhibitions not necessarily limited to the productions of the Photo-Secessionists or to American work." [75]

Post received a copy of the newsletter but did not find his name listed as a member. This prompted him to write a pointed inquiry to Stieglitz on January 7, 1903: "Am I to understand it as an invitation to join or is it a notification of election? As I read over the paper it appears to be a clique who vote to themselves absolute command for all time, but who wish outsiders (like myself) to come in under the name of 'Associates.' This class will have to pay $5.00 per annum and also to bind themselves to pay, pro rata, for all the mistakes of the first class called 'Fellows' and 'Council.' It seems to me also that a member binds himself to do nothing in the way of showing his work, without first asking permission of the aforesaid clique. Who is the director? In what class am I invited to join and if I accept what are my financial obligations?" He questioned why two minor photographers—Dallett Fuguet and John Francis Strauss—deserved to be on the exclusive "Council" and then, inexplicably, told Stieglitz he did not expect a reply to his letter. [76]

Post's resentfulness may reflect a lack of confidence in his new work or insecurity about his standing among his more active peers. His concern about the financial obligations of joining the group, however, is somewhat surprising, since he was still a wealthy man at the time. Perhaps, as a married man, he was just watching his funds more carefully.

In any event, his letter to Stieglitz got results. The very next issue of the Photo-Secession's newsletter listed Post as an elite "Fellow," elected on February 13, 1903. He was the only member from Maine; the other forty-four members resided primarily in New York and Philadelphia.

Post contributed work to most of the shows the Photo-Secession organized or participated in. Consequently, he was represented in many of the finest photography exhibitions held during the first decade of the twentieth century. These included major Photo-Secession shows at art museums in New England, galleries in New York City, and international expositions in this country and abroad. In 1903, the year he joined the Photo-Secession, Post successfully sent work to at least nine exhibitions—the most he had entered since 1896—in the United States, England, France, Germany, Belgium, and Russia.

Stieglitz, as director of the Photo-Secession, organized about half a dozen large-scale exhibitions of pictorial photography between 1902 and 1910, and most of them included pictures by Post. In 1904, two years after the inaugural show at the National Arts Club, Stieglitz presented Photo-Secession exhibitions at the Corcoran Gallery of Art in Washington, D.C., and the Carnegie Institute in Pittsburgh, two of the nation's most prestigious art museums. These shows,

held one after the other, featured much of the same work, including Post's accomplished water-lily and winter scenes. Sadakichi Hartmann, writing in *Camera Work*, declared the Pittsburgh show "indisputably the most important and complete pictorial photography exhibition ever held in this country." [77] In a review in another magazine, he noted that the exhibition contained many landscapes and that Post was one of the genre's leading practitioners.

In 1909, Stieglitz returned to the National Arts Club to present another exhibition of pictorial photography, which was international in scope and again included two of Post's pictures. Then, a year later, Stieglitz began organizing what would be his last major group show of pictorial photographs, to be held at the Albright (now Albright-Knox) Art Gallery, in Buffalo, New York. Reading about the upcoming "International Exhibition of Pictorial Photography" in the April 1910 issue of *Camera Work*, Post recognized that the show would be Stieglitz's greatest accomplishment yet. "Your Buffalo show will be a great thing," he wrote Stieglitz, "and will hit hard in places where it should. You are certainly very hard to dowse and your bravery is beginning to bring you the fruits of victory." [78] Wishing to ensure a good representation in the exhibition, he then offered to send any images Stieglitz desired.

Post correctly predicted the importance of the Buffalo exhibition. Critics like Hartmann and Charles H. Caffin praised the quality of the photographs,

the show's comprehensiveness, and the installation, which took up most of the museum and allowed visitors to view all of an individual artist's works together. Post was one of twenty-eight exhibitors in the juried open section, which also included photographs by Pierre Dubreuil, Arnold Genthe, and Karl F. Struss. Post's three pictures compared well to photographs in the more exclusive invitational section. More than one writer in the photographic press praised his subtle platinum prints of winter. The reviewer for *Photo Era* appreciated the charming light in his pictures, and Joseph T. Keiley, a fellow Photo-Secessionist, commented, "William B. Post's snow studies were gems, as beautiful as anything of his that I have ever seen." [79]

Five years before that epic exhibition, Stieglitz had established the Little Galleries of the Photo-Secession in New York. Over the next dozen years, the Little Galleries (later known as "291" after its street address) presented one-person and group exhibitions of photographs, paintings, drawings, and sculpture. Post participated in most of the annual Photo-Secession exhibitions held there but never had a solo show, a privilege accorded only seven photographers during the gallery's entire existence.

In the first members' exhibition at the Little Galleries, held in late 1905, Post contributed two winter scenes, the type of work he most frequently showed there. Two years later, he lamented that the group's annual show was full of portraits and had few landscapes. He also

complained to Stieglitz about how his picture had been treated: "I am very much disappointed. I do not object to your trimming my print, although it was somewhat of a nerve. What I do object to is your changing the title. I sent you no picture called *Snow Flurry* and therefore do not know which of mine was hung. I insist on naming my work myself."[80] Post had photographs in subsequent members' shows, which usually featured only one hundred prints, making every work accepted significant.

Stieglitz included Post's images in another type of Photo-Secession show— the loan collection. As the leading American pictorialist group, the Secession received many invitations to participate in comprehensive photography and art exhibitions. To accommodate these requests, Stieglitz put together numerous small groupings of pictures that he shipped around the country and to Europe. This gained Post a wider audience for his work, especially in the Secession's early years. In 1903, Post's photographs were in Photo-Secession loan collections that went to Cleveland, Chicago, and Denver. By that time, most European pictorialists had seen the selections Stieglitz sent to Hamburg, The Hague, and elsewhere in Europe and had conceded that American work was better than theirs. In 1905, Post had pictures in Photo-Secession displays at the Lewis and Clark Exposition in Portland, Oregon, and the annual photography exhibition at the Worcester Art Museum in Worcester, Massachusetts. Stieglitz always insisted that all images in

a loan collection be hung together, which highlighted the strength of the group as a whole and also accentuated the uniqueness of each contributor's work.

Stieglitz published *Camera Work* as the Photo-Secession's mouthpiece, and it soon became the organization's most tangible product. Issued quarterly from 1903 to 1917, *Camera Work* simultaneously fought for and chronicled pictorial photography in America. It contained significant articles about the developing aesthetics of photography and, more important, richly printed and delicately presented photogravure illustrations. Pictorialists knew they had arrived, artistically speaking, when Stieglitz featured their work in the magazine.

Post subscribed to *Camera Work* from its inception and aspired to be immortalized in its pages. Upon seeing the first issue, he told Stieglitz, "[It] is simply immense and it is hard to conceive of anything finer, and I congratulate you from the bottom of my heart."[81] However, he went on to say that he hoped Stieglitz would not reproduce only the work of a few key players, like Käsebier, whose illustrations dominated the first issue.

Post's fear of being excluded was unfounded, for less than a year and a half later, Stieglitz presented *Wintry Weather* (plate 6) in *Camera Work* as a full-page gravure. The April 1904 issue, in which that image appeared, also featured five gravures by Alvin Langdon Coburn and the magazine's usual assortment of poems, exhibition reviews, and articles on photography and the other arts. An unsigned

editorial described Post's picture as "a capital example of the snow-pictures through which Mr. Post has made himself famous in photography."[82]

Wintry Weather is one of the strongest images Post ever made. Like much of his other work, it has a prominent foreground, gently modulated only by shadows and demarcations in the snow. Skillfully evoking the silence of the rural setting by the merest hint of a human presence, he produced a study essentially of planes in shades of light and dark.

Wintry Weather was subsequently reproduced a number of times in the photographic press. The year after its publication in *Camera Work*, it appeared in Charles Holme's *Art in Photography*, a deluxe volume printed in England with tipped-in illustrations by prominent American and European pictorialists. In 1912, the *Photographic Times* pictured it in an article on winter photography. And the German critic Adolf Miethe included it in at least two editions of his book *Künstlerische Landschaftsphotographie.*

Post kept informed of Photo-Secession activities by receiving the group's sporadic newsletter, reading *Camera Work*, and occasionally corresponding with Stieglitz directly. By 1907, however, Post was feeling isolated. "I am a back number," he confided to Stieglitz, "and the doors of everything are shut to me now."[83]

The next year Stieglitz and Post had a falling out, something many other Photo-Secessionists also experienced, and that unfortunate event further distanced Post from the New York photography scene.

The rift can be reconstructed only through Post's correspondence, because Stieglitz's 1908 letters to Post have never been found. By late that year, Post must have written something to Stieglitz that offended him deeply. According to Post, Stieglitz then sent him a letter with an "extravagance of adjectives" in which he declared Post's work inferior and asked him to resign from the Photo-Secession. On December 15, Post wrote a lengthy response in which he apologized to Stieglitz and asked for the return of some prints. "I shall be very careful never to take one minute of your time," he concluded, "even if it becomes necessary not to again show any work in the Photo-Secession."[84] This concession must have been painful for Post, especially since earlier that year he had demonstrated his outrage at Stieglitz's expulsion from the Camera Club of New York by giving up his own life membership in that organization. Whether or not Post ever formally withdrew from the Photo-Secession remains unknown, but he did cancel his subscription to *Camera Work*, a signal that the break was real and a reconciliation improbable.

THE PORTLAND CAMERA CLUB

DESPITE POST'S DEDICATION TO Stieglitz and the Photo-Secession, he was also involved with the Portland Camera Club during much of the same time. He undoubtedly joined the club for the camaraderie of its members and the exhibition opportunities it offered. Between 1904 and 1909, he presented a one-person exhibition at the club and participated in members' shows that were seen in Maine and elsewhere.

Founded in 1899, the Portland Camera Club was a recognized force in amateur photography by the time Post became affiliated with it. In 1907, Frank Roy Fraprie wrote a lead article in *American Amateur Photographer* on the seventy-five-member club, calling it "one of the most energetic and progressive organizations of the kind in New England, if not in the entire United States." [85] And because Portland is a seaport near mountains, fields, and woods, many of its members excelled at capturing the open-air effects of land and water. During the 1910s and 1920s, club members Francis O. Libby and Rupert S. Lovejoy enjoyed national reputations with their sensitive prints of such subjects.

Post debuted his work at the club in May 1904 with a stunning solo show of seventy platinum prints. Although he chose to feature his medal-winning snow scenes, he also included *The Critic* (see p. 27, fig. 7). *The Portland Daily Advertiser*

considered the show the best the club had ever presented and devoted half a page to it on the Sunday after it closed. The paper said Post's pictures rivaled the work of painters and declared them "real works of art, effects which it has been thought could only be gained with the brush." [86] Another Portland paper agreed, noting that Post had selected images "with a view of showing people what can be done with a camera as an instrument for doing artistic work" and calling him "essentially a camera artist." [87] The writer was confident that others interested in the poetic possibilities of photography would be inspired by Post's work and ended the review by quoting Shakespeare.

Post also contributed photographs to members' exhibitions that traveled to other cities. In 1907, the Portland Camera Club's annual show of seventy-five prints was seen in Boston, where it was thought one of the most attractive photographic displays the city had presented in recent years. In a detailed review, *Photo Era* enthusiastically discussed Post's work first. "The winter landscapes of W. B. Post were distinguished by that absolute mastery of technique which makes the beholder forget that there is such a thing as workmanship. It is the spontaneous, impersonal quality, the art that conceals art, together with a marked sense of poetic beauty, which places such pictures as *Drifted Road* and *Lengthening Shadows*

on a level with the noblest productions of the etcher's art."[88]

Post's work was included in the Portland club's next two members' shows, which were displayed both in Portland and at the Boston Camera Club. When the club sent a group of pictures to the Worcester Art Museum for its annual exhibition of photographs in 1907, two of Post's were among them. It remains unclear how often Post actually took the forty-five-mile train trip to Portland to spend time at the club. Still, it seems the relationship between Post and the club was mutually beneficial, each gaining from the other's stature.

DARK PRESENTATIONS BY A RECLUSIVE PERSONALITY

POST PRESENTED MOST OF HIS finished photographs on dark mounts and in dark frames. He carefully matched the color of his mounts to the color of his platinum prints, which were toned either gray or brown. Many pictorialists attached their photographs to multiple sheets of different-colored paper, each cut slightly larger than the one in front of it. This practice, which sometimes eliminated the need for a frame, was common among Americans, although Frederick H. Evans, of England, became one of its leading practitioners. Post, however, usually preferred the simplicity of a single backing, which he then put into a frame.

Likewise, Post matched the color of his wood frames to the mounts and prints, producing pleasing combinations that most viewers appreciated. Sadakichi Hartmann, for instance, considered the gray and silver frames in Post's 1900 solo show at the Camera Club of New York superb. Two years later, the editor of

Photo Beacon, reviewing the third Chicago Photographic Salon, remarked on the way Post had framed his snow and water pictures. Post "uniformly adheres to a dainty gray effect which is enhanced by frames of the same color," he wrote, "and the result is both happy and successful."[89]

Post, who by 1909 had hundreds of pictures hanging in his Fryeburg house, frequently sent both his own work and the photographs he collected to George F. Of in New York for framing. An advertiser in every issue of *Camera Work*, Of was a distinguished framer recommended by Stieglitz and used by many other Photo-Secessionists. His frames bear his label on the back (fig. 11). In 1901, the *Photographic Times* honored Of by reproducing a frontispiece by John H. Gear in one of his frames. "Mr. Of has long held the reputation of being something more than a mechanical frame-maker," the magazine editorialized. "His artistic judgement can always be relied upon."[90]

Fig. 11. Label of framer George F. Of

Over the years, Of worked at various addresses in the vicinity of the Photo-Secession's Little Galleries on Fifth Avenue.

Post's taste and Of's craftsmanship are evident in a surviving example of their combined work (frontispiece). For Post's subtle platinum print, Of made a double gray frame that elegantly complements the image. He placed the print in a simple, thin molding, which he then surrounded with an expanse of flat gray wood that enhances the picture's exaggerated foreground. With its open oak grain and abstracted border decoration, this 8½-by-9-inch frame evokes the Arts and Crafts style so popular at the time.

Post's quiet images seem to reflect his reticent personality, and the subdued tonalities of his prints accord with the low profile he preferred to keep in the photographic community. When he lived in New York, he rarely sat on committees or sought leadership roles in the camera clubs he joined. After he moved to Maine, his isolation led him to become increasingly selective in his photographic activities. In late 1899, just months after his collection of photographs was written up in *Camera Notes*, he declined to participate in the Camera Club of New York's presentation of similar private collections. When he was exhibiting with the Portland Camera Club, he often did not allow his images to be reproduced by the press. In 1907, Post's wife went to New York and met with Stieglitz at the Photo-Secession galleries, while Post stayed at home. Two years later, a long newspaper article about him pointed out that Post had successfully "escaped public notice here in Maine."[91] It seems he rarely ventured far from Fryeburg, a habit that prompted a recent scholar of the Photo-Secession to label him "a wealthy recluse."[92]

THE LAST YEARS

AFTER POST EXHIBITED IN THE important show of 1910 that Stieglitz organized for the Albright Art Gallery, less and less was heard from him. During the last decade of his life, he seldom allowed his work to be exhibited or

reproduced, although Sadakichi Hartmann included a few of Post's landscapes in articles he wrote for the *Photographic Times*. In 1914, Post himself wrote an article, illustrated with his images of water lilies, a subject he was still photographing. By then, he had apparently stopped exhibiting his own work in Portland, although he did display thirty-four photographs from his private collection in 1912 at the city's Sweat Memorial Art Museum.[93] During the 1910s, few people knew about him, largely because of his retiring lifestyle. Writing in 1912, Hartmann referred to him as a "veteran snow depicter,"[94] suggesting Post's days as a practicing photographer were numbered.

Yet Post experienced a brief flurry of activity in 1921, the year he died. In January, *Photo Era* reproduced one of his new landscapes and called him "a master of winter-scenes in their loveliest aspect— as they impressed him individually."[95] In February, he received his first word from Stieglitz in years—notice of a one-person exhibition Stieglitz was having in New York. Post wrote back, "I was heartily glad to get your card, as there is a note of cheerfulness in it," and wished him success with the show.

Then, later that month, Post exhibited his own work, possibly for the first time since 1910. According to a label on the back of one of his mounts, he was represented in a large exhibition of pictorial photographs in Missouri at the Kansas City Photographic Supply Company— a show subsequently installed at the Kansas City Art Institute. It comprised nearly two hundred photographs by Louis Fleckenstein, Rupert S. Lovejoy, Margrethe Mather, Wilbur H. Porterfield, Edward Weston, and other photographers a generation younger than Post.[96]

By 1921, however, Post was no longer financially secure. Although he had never attempted to make photography a profession, he had come to rely on the income from print sales to make ends meet. In February, he told Stieglitz he had sold up to two hundred photographs in a year, but only at the meager price of two dollars each, a far cry from what he had lavished on the work of others when he was collecting. "Photography for me," he wrote, "cannot be a success in the way I now most desire, i.e., money. I am a very poor man."[97]

Four months later Post was gone, dying peacefully in his sleep on June 12 at the age of sixty-four. The front page of Fryeburg's *Reporter* stated that the community was shocked to hear of the passing of "one of our highly respected townsmen."[98] But no photography magazine gave him an obituary, an indication of the obscurity into which he had fallen. And within a few years, his penniless widow had to sell their house and move in with relatives.

While Post's estate was cash poor, it was exceedingly rich artistically. His quiet landscapes form a unified and enduring testament to creative camera work and eloquently convey the spirit of one photographer's solitary communion with nature, one hundred years ago. ❧

NOTES

1. Stieglitz to Post, July 10, 1894, collection of Mary Weston.

2. Stieglitz to Post, July 2, 1894, collection of Mary Weston.

3. Most modern sources mistakenly give Post's year of death as 1925.

4. Application of William B. Post, New York Stock Exchange, July 28, 1887, New York Stock Exchange Archives.

5. "Informal Exhibition of Prints at Society of Amateur Photographers," *Anthony's Photographic Bulletin* 20 (January 26, 1889): 50.

6. E. W. N., "The New York Camera Club," *Photographic Times* 19 (January 18, 1889): 34.

7. "The Philadelphia Exhibition," *Anthony's Photographic Bulletin* 20 (April 23, 1889): 226.

8. William B. Post, journal of trip to California and Japan (January 7–October 6, 1891), August 31, 1891, collection of Mary Weston.

9. Ibid., January 7, 1891.

10. Ibid., March 8, 1891.

11. Ibid., March 4, 1891.

12. Ibid., February 7, 1891.

13. Ibid., April 11, 1891.

14. Ibid., May 6, 1891.

15. Ibid., June 21, 1891.

16. Ibid., July 29, 1891.

17. Ibid., June 27, 1891.

18. Ibid., August 31, 1891.

19. Ibid., July 10, 1891.

20. Ibid., October 6, 1891.

21. Catherine Weed Barnes, "Personal," *American Amateur Photographer* 3 (November 1891): 464.

22. Alfred Stieglitz, "The Joint Exhibition at Philadelphia," *American Amateur Photographer* 5 (June 1893): 251.

23. William B. Post, notebook of exhibitions, "Slides and Prints in Competition," 1893–1908, collection of Mary Weston.

24. H. McBean Johnstone, "Hand-Camera Memoranda for Pictorial Purposes," *Photographic Times* 32 (August 1900): 337–40.

25. Henry Peach Robinson, "Foregrounds," *Photographic Times* 27 (July 1895): 2.

26. Dorothy Norman, "From the Writings and Conversations of Alfred Stieglitz," *Twice a Year*, no. 1 (Fall–Winter 1938): 96.

27. Stieglitz, "Joint Exhibition at Philadelphia," p. 251.

28. "Society of Amateur Photographers of New York," *American Amateur Photographer* 4 (December 1892): 558.

29. William B. Post, "Photographic Exhibition of the 23rd Regiment Fair," *American Amateur Photographer* 6 (December 1894): 567.

30. Ibid.

31. Ibid.

32. Ibid.

33. "The Camera Club of Hartford," *Photographic Times* 24 (February 16, 1894): 108.

34. Alfred Stieglitz, "The Seventh Joint Exhibition," *American Amateur Photographer* 6 (May 1894): 215.

35. Stieglitz to Post, July 2, 1894, collection of Mary Weston.

36. Joseph Obermeyer, "Members' Exhibition of Photographs: New York Camera Club," *American Amateur Photographer* 7 (May 1895): 222.

37. Walter D. Welford, "American Exhibitors in Europe," *Photographic Times* 28 (September 1896): 409–11.

38. Jean-François Millet, quoted in Peter Henry Emerson, *Naturalistic Photography for Students of the Art* (London: Sampson Low, Marston, Searle and Rivington, 1889), pp. 87–88.

39. This kind of hand-drawn addition, called a "remarque," was popular with printmakers during the etching revival of the late nineteenth century.

40. "The 1898 American Institute Exhibition of Photographs," *American Amateur Photographer* 10 (October 1898): 459.

41. Alfred Stieglitz, "The Platinotype Process and the New York Amateur," *Photographic Times* 3 (April 1892): 154.

42. "S. L. Post's Sudden Death: Stricken with a Fatal Illness on the Floor of the Stock Exchange Yesterday," *New York Times*, June 4, 1897, p. 12.

43. John Stuart Barrows, *Fryeburg, Maine, An Historical Sketch* (Fryeburg, Maine: Pequawket Press, 1938), p. 144.

44. Sidney Allan [Sadakichi Hartmann], "Winter Photography," *Photographic Times* 44 (March 1912): 85.

45. William S. Davis, "Some Notes on Snow and Ice Photography," *Photographic Times* 40 (December 1908): 370.

46. Post journal, March 27, 1891, collection of Mary Weston.

47. Sadakichi Hartmann, "Exhibition of Prints by Wm. B. Post," *Camera Notes* 4 (April 1901): 277.

48. William B. Post, "Photography of the Snow," *Photo Era* 24 (March 1910): 113.

49. Ibid., p. 119.

50. William B. Post, "Picturing the Water-Lily," *Photo Era* 33 (August 1914): 73.

51. Ibid., p. 74.

52. Hartmann, "Exhibition of Prints by Wm. B. Post," p. 278.

53. Theodore Dreiser, "The Camera Club of New York," *Anslee's Magazine* 4 (October 1899): 326.

54. Our Illustrations, *Camera Notes* 2 (July 1898): 18.

55. Post to Stieglitz, September 29, 1898, Stieglitz Archive, Collection of American Literature, Beinecke Rare Book and Manuscript Library, Yale University, New Haven, Connecticut.

56. "The Post Collection of Pictorial Photographs," *Camera Notes* 2 (January 1899): 96.

57. Post to Stieglitz, May 31, 1898, Beinecke Rare Book and Manuscript Library.

58. Post to Stieglitz, December 12, 1898, Beinecke Rare Book and Manuscript Library.

59. Post to Stieglitz, December 20, 1898, Beinecke Rare Book and Manuscript Library.

60. These include, from 1899, "The Post Collection of Pictorial Photographs," in *Camera Notes*, and *Portland Society of Art: Annual Exhibition of Photographic Section* (Portland, Maine: L. D. M. Sweat Memorial Art Museum, 1912), a checklist for an exhibition that featured thirty-four photographs lent by Post.

61. See Weston J. Naef, *The Collection of Alfred Stieglitz* (New York: Metropolitan Museum of Art and Viking Press, 1978).

62. Christian A. Peterson, "George Timmins' Early Collection of Pictorial Photography," *History of Photography* 6 (January 1982): 21–27.

63. E. Lee Ferguson, "Our Lack of Exhibitions," *Camera Notes* 1 (October 1897): 28.

64. Quoted in Joseph T. Keiley, "The Pictorial Movement in Photography and the Significance of the Modern Photographic Salon," *Camera Notes* 4 (July 1900): 22.

65. W. P. L., "The Photographic Salon, Pennsylvania Academy of Fine Arts," *Photographic Times* 32 (November 1900): 516.

66. Sadakichi Hartmann, "On Exhibitions," *Camera Notes* 5 (October 1901): 109.

67. Hartmann, "Exhibition of Prints by Wm. B. Post," p. 277.

68. Ibid., p. 278.

69. Post to Stieglitz, September 3, 1899, Beinecke Rare Book and Manuscript Library.

70. Post to Stieglitz, January 26, 1902, Beinecke Rare Book and Manuscript Library.

71. Post to Stieglitz, December 29, 1902, Beinecke Rare Book and Manuscript Library.

72. William B. Post, "Picturing the Pond-Lily," *Photo Era* 33 (August 1914): 76.

73. Post to Stieglitz, December 15, 1908, Beinecke Rare Book and Manuscript Library.

74. Reprinted in "The 'Photo-Secession' at the Arts Club," *Camera Notes* 6 (July 1902): 34.

75. [Alfred Stieglitz], "The Object of the Photo-Secession Is," *The Photo-Secession*, no. 1 (December 1902): 1.

76. Post to Stieglitz, January 7, 1903, Beinecke Rare Book and Manuscript Library.

77. Sadakichi Hartmann, "The Photo-Secession Exhibition at the Carnegie Art Galleries, Pittsburgh, Pa.," *Camera Work*, no. 6 (April 1904): 47.

78. Post to Stieglitz, May 18, 1910, Beinecke Rare Book and Manuscript Library.

79. Joseph T. Keiley, "The Buffalo Exhibition," *Camera Work*, no. 33 (January 1911): 28.

80. Post to Stieglitz, November 18, 1907, Beinecke Rare Book and Manuscript Library.

81. Post to Stieglitz, December 29, 1902, Beinecke Rare Book and Manuscript Library.

82. Our Illustrations, *Camera Work*, no. 6 (April 1904): 51.

83. Post to Stieglitz, October 11, 1907, Beinecke Rare Book and Manuscript Library.

84. Post to Stieglitz, December 15, 1908, Beinecke Rare Book and Manuscript Library.

85. Frank Roy Fraprie, "The Portland Camera Club," *American Amateur Photographer* 19 (June 1907): 291.

86. "Remarkable Photographs: Pictures by W. B. Post at Portland Camera Club Room Wonderful," *Portland (Maine) Daily Advertiser*, May 28, 1904.

87. "Fine Exhibition at Camera Club of Work of W. B. Post," *Portland (Maine) Daily Eastern Argus*, May 28, 1904, p. 8.

88. "Exhibition of the Portland Camera Club," *Photo Era* 18 (June 1907): 314.

89. F. Dundas Todd, "Brief Criticism of the Pictures in Chicago Salon," *Photo Beacon* 15 (February 1903): 40.

90. "An Artistic Frame-Maker," *Photographic Times* 33 (June 1901): 281.

91. "Fryeburg Photographer Wins Many Foreign Honors," unidentified newspaper, October 26, 1909, collection of Mary Weston.

92. Naef, *Collection of Alfred Stieglitz*, p. 122.

93. *Portland Society of Art: Annual Exhibition of Photographic Section*.

94. Allan [Hartmann], "Winter Photography," p. 88.

95. Wilfred A. French, Our Illustrations, *Photo Era* 46 (January 1921): 44.

96. "Kansas City Pictorial Exhibition," *Photo Era* 46 (April 1921): 213–14.

97. Post to Stieglitz, February 2, 1921, Beinecke Rare Book and Manuscript Library.

98. "William B. Post," *Fryeburg (Maine) Reporter*, June 16, 1921, p. 1.

PLATES

All photographs are platinum prints by William B. Post, from the
collection of The Minneapolis Institute of Arts. They were acquired in 2002
through the museum's McClurg Photography Purchase Fund.

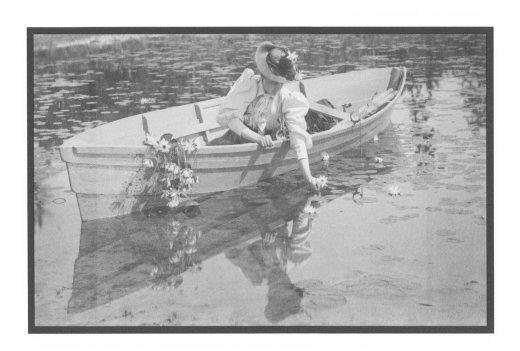

1

Summer Days
c. 1895
5 $3/8$ × 9 $7/16$ inches

2002.69.50

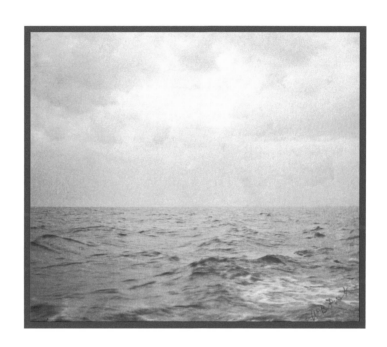

2

Untitled
c. 1891
3 3/8 × 3 7/8 inches

2002.69.51

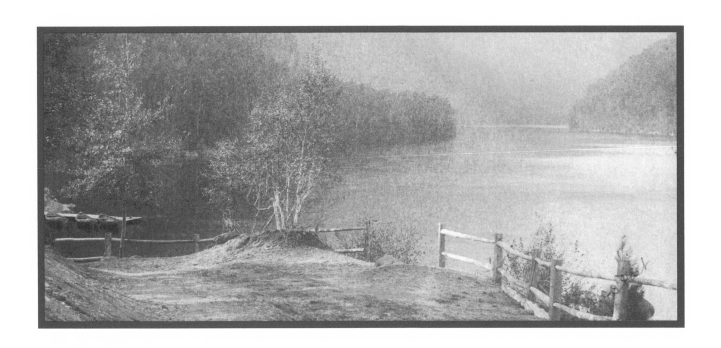

3

Untitled
c. 1900
$2^9/_{16} \times 5^3/_4$ inches

2002.69.42

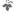

Intervale, Winter
1899
$7^5/_{16} \times 9^7/_{16}$ inches
2002.69.9

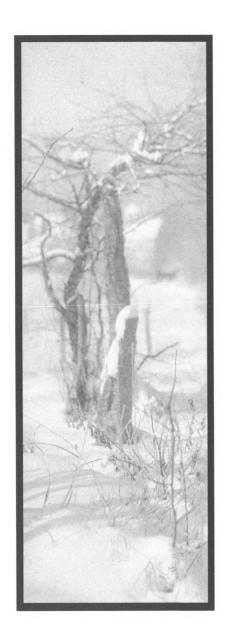

5

Untitled
c. 1900
8³/₈ × 3³/₁₆ inches

2002.69.27

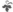

6

Wintry Weather
c. 1903
5^{15}/$_{16}$ × 6^{7}/$_{8}$ inches
2002.69.11

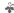

7

Untitled
c. 1900
3 3/4 × 9 3/8 inches
2002.69.17

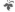

8

Untitled
c. 1900
$7^{15}/_{16} \times 3^{7}/_{8}$ inches
2002.69.23

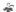

9

Untitled
c. 1900
7¼ × 6 inches
2002.69.19

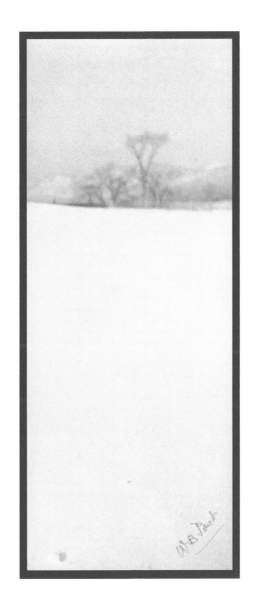

10

Untitled
c. 1900
$7^{5}/_{16} \times 2^{15}/_{16}$ inches
2002.69.24

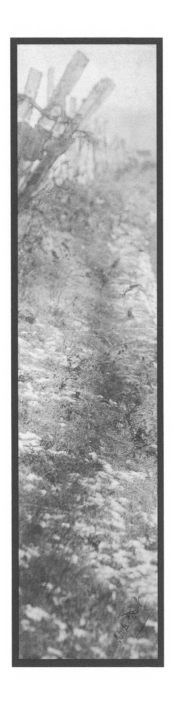

11

Untitled
c. 1900
$8^{13}/_{16} \times 2^{1}/_{8}$ inches

2002.69.20

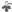

12

Untitled
c. 1900
5 ¾ × 7 ⅜ inches
2002.69.3

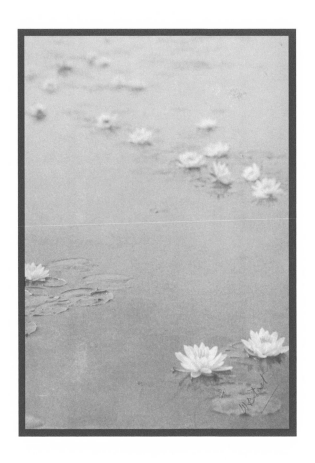

13

Untitled
c. 1900
$6^{13}/_{16} \times 4^{13}/_{16}$ inches
2002.69.37

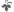

14

Untitled
c. 1900
9 ³/₈ × 3 inches
2002.69.40

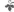

15

Untitled
c. 1900
3 5/8 × 9 7/16 inches
2002.69.35

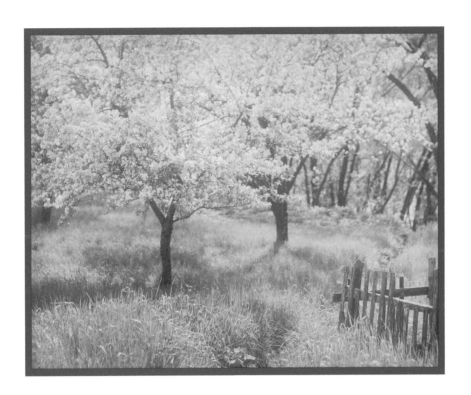

16

Untitled
c. 1900
7^{9}/$_{16}$ × 9^{1}/$_{2}$ inches
2002.69.15

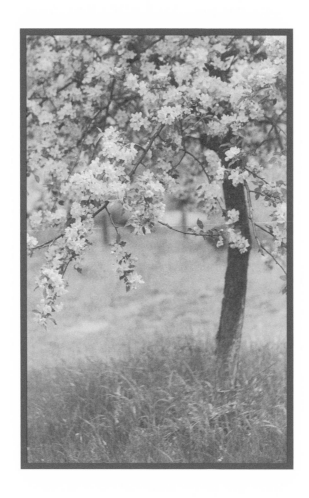

17

Untitled
c. 1900
8³/₈ × 5⁵/₁₆ inches
2002.69.13

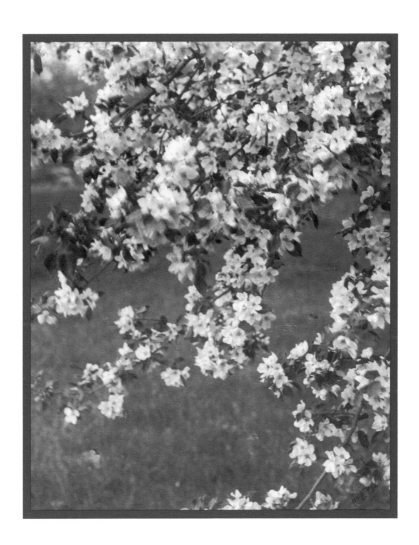

18

Untitled
c. 1900
9 3/8 × 7 7/16 inches
2002.69.53

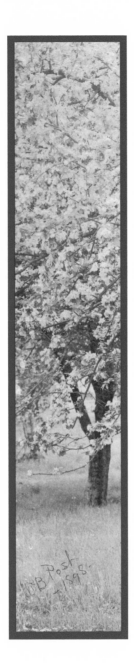

19

Untitled
1898
7⁷⁄₈ × 1³⁄₈ inches

2002.69.32

❧

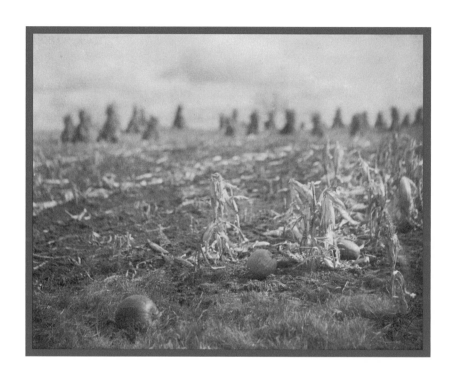

Aftermath
c. 1900
7 3/8 × 9 7/16 inches

2002.69.56

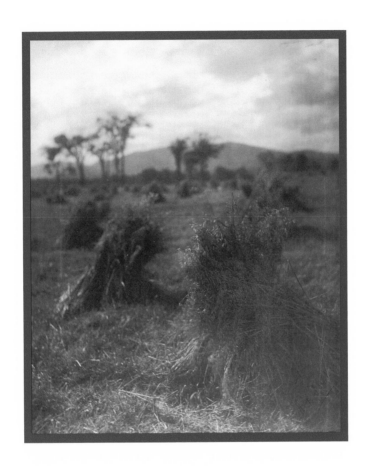

As Daylight Fails
c. 1900
9^5/$_{16}$ × 7^9/$_{16}$ inches
2002.69.57

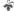

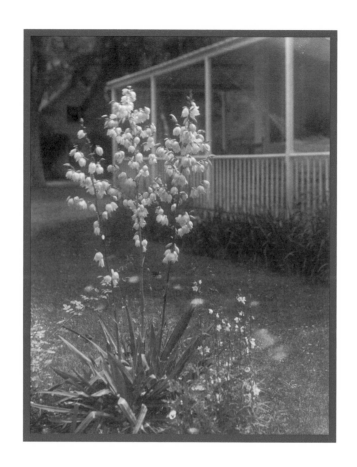

22

Untitled
c. 1900
9^{5}/$_{16}$ × 7^{7}/$_{16}$ inches
2002.69.16

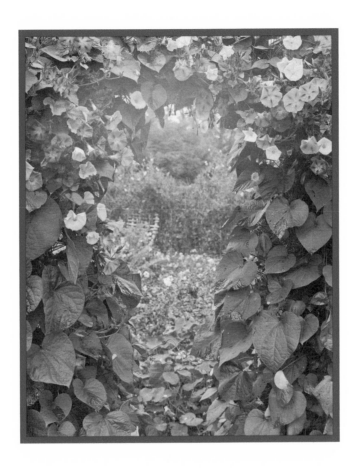

23

Entrance to Mary's Garden
c. 1900
8⁷/₈ × 7 inches
2002.69.12

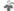

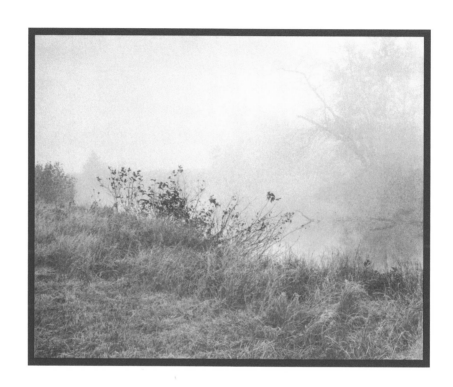

24

Fog and Frost
c. 1900
7$\frac{1}{2}$ × 9$\frac{3}{16}$ inches
2002.69.44

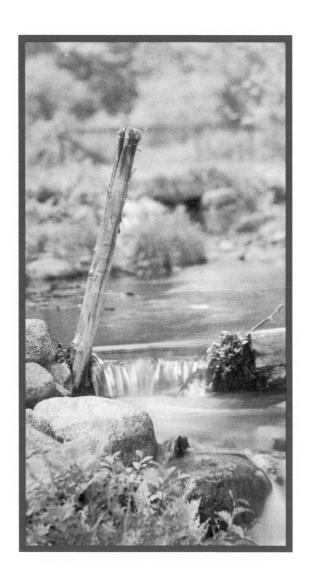

25

Untitled

c. 1900

$7^{3}/_{16} \times 3^{15}/_{16}$ inches

2002.69.22

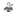

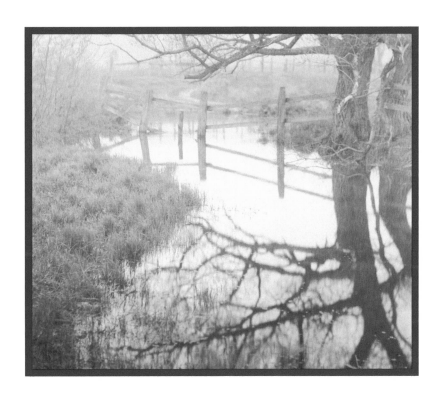

26

Untitled
c. 1900
6$^5/_8$ × 7$^5/_8$ inches

2002.69.31

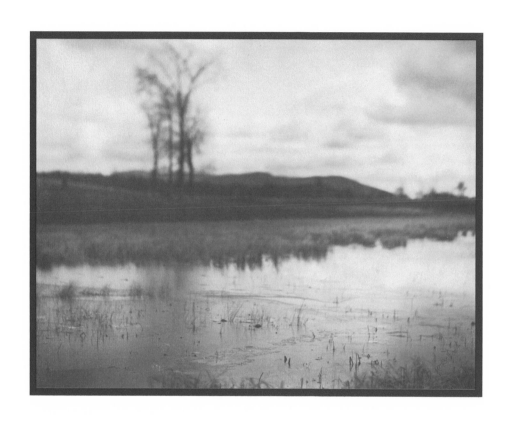

27

October Morning
c. 1900
7 1/8 × 9 1/4 inches
2002.69.5

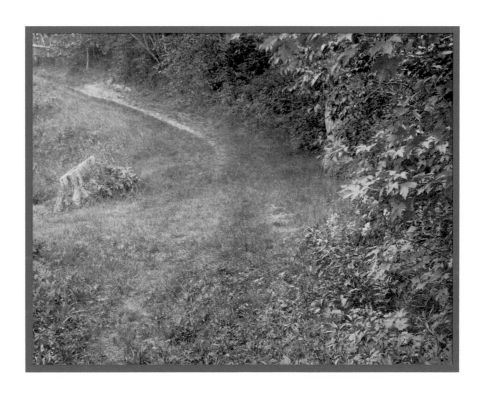

28

Untitled
c. 1900
$7\,^{7}/_{16} \times 9\,^{11}/_{16}$ inches
2002.69.46

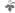

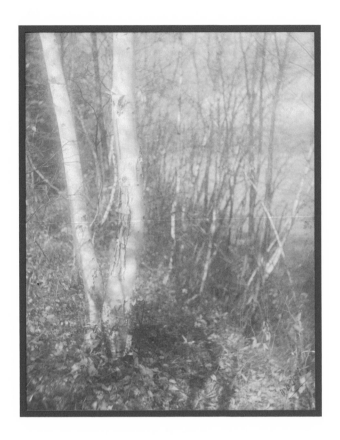

29

Forest Edge
c. 1900
9 5/8 × 7 1/2 inches
2002.69.45

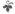

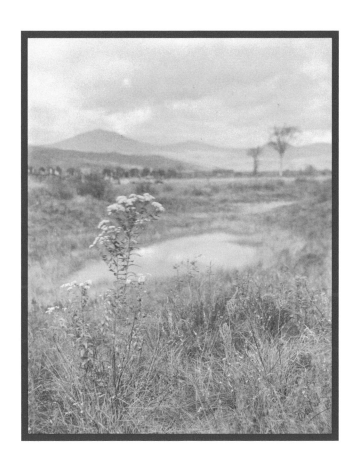

30

Wild Aster

c. 1900

$9^{5}/_{16} \times 7^{3}/_{8}$ inches

2002.69.1

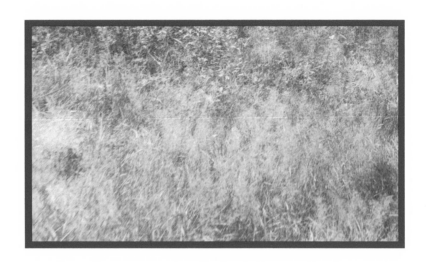

31

Untitled
c. 1900
$2^5/_{16} \times 4^1/_8$ inches
2002.69.6

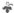

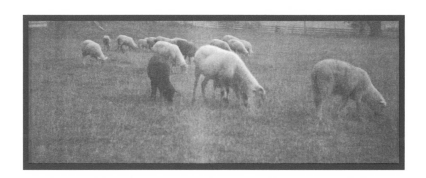

32

Untitled
c. 1900
$1^{11}/_{16} \times 4^7/_{16}$ inches
2002.69.7

33

Untitled
c. 1900
$8^{3}/_{8} \times 6^{7}/_{16}$ inches
2002.69.49

CHRONOLOGY

1857
Born on December 26 in New York

1861
Mother dies

1880
Becomes a partner in Homas and Company, a New York brokerage firm

c. 1885
Begins photographing

1887
Obtains a seat on the New York Stock Exchange

1888
Member of the Society of Amateur Photographers of New York and the New York Camera Club

c. 1890
Sails to Bermuda

1891
Goes to California and Japan for nine months

1892
One-person screening of his lantern slides at the Society of Amateur Photographers of New York

c. 1892
Travels to the Bahamas

1893
Shows Alfred Stieglitz how to use a hand camera, then lends him his equipment

1894
Writes a review for *American Amateur Photographer* about the photography section of the 23rd Regiment Fair in Brooklyn, New York

1896
Founding member of the Camera Club of New York

More of his work published than in any other year

1897
Sells his seat on the New York Stock Exchange shortly after his father's death

c. 1898
Begins collecting photographs

1898
Moves to Fryeburg, Maine

Photogravure published in *Camera Notes*

1899
Photogravure in *American Pictorial Photography*, *Series I*, a portfolio published by the Camera Club of New York

Temporarily stops photographing after a medical operation

1900

One-person exhibition at the Camera Club of New York

1901

Photogravure published in *Camera Notes*

Marries Mary Webster Weston

1902

Resumes photographing

Exhibits in "American Pictorial Photography Arranged by the Photo-Secession" at the National Arts Club in New York

1903

Elected to membership in the Photo-Secession

1904

Photogravure published in *Camera Work*

One-person exhibition at the Portland Camera Club in Portland, Maine

1905

Participates in the first members' exhibition at the Little Galleries of the Photo-Secession in New York

1908

Resigns his life membership in the Camera Club of New York in protest of Alfred Stieglitz's expulsion

Rift with Stieglitz

1910

Writes an article on photographing snow for *Photo Era*

Participates in the "International Exhibition of Pictorial Photography" at the Albright Art Gallery in Buffalo, New York

1912

Exhibits work from his collection at the L. D. M. Sweat Memorial Art Museum in Portland, Maine

1914

Writes an article on photographing water lilies for *Photo Era*

1921

Exhibits at the Kansas City Photographic Supply Store and the Kansas City Art Institute in Kansas City, Missouri

Dies in his sleep on June 12 in Fryeburg, Maine

LISTINGS OF PHOTOGRAPHS REPRODUCED IN POST'S LIFETIME

If the title is known but not given in the publication cited, it appears in boldface type within brackets. Bracketed information in lightface type identifies the subject but is not a title.

A Study from Life, photogravure, *Photographic Times* 19 (January 18, 1889), frontispiece.

Yokohama from "One Hundred Steps," halftone, *American Amateur Photographer* 4 (May 1892): 185.

The Canal and Street, Yokohama, halftone, *American Amateur Photographer* 4 (May 1892): 186.

Temple and Stone Lanterns, halftone, *American Amateur Photographer* 4 (May 1892): 188.

The Seal Rocks, Monterey, photogravure, *American Amateur Photographer* 4 (June 1892), frontispiece.

Japanese Girl, halftone, *American Amateur Photographer* 4 (December 1892), frontispiece.

Marine, photogravure, *American Amateur Photographer* 5 (March 1893), frontispiece.

Architectural Study, halftone, *American Amateur Photographer* 5 (April 1893), frontispiece.

Evening at Nassau, halftone, *American Amateur Photographer* 5 (April 1893), frontispiece.

Moonlight on the Quay, halftone, *Photographic Times* 23 (December 15, 1893): 730.

Japanese Girls, halftone, *American Amateur Photographer* 6 (February 1894): 59.

At the Edge of the Wood, halftone, *American Amateur Photographer* 6 (February 1894): 61.

From Japan, halftone, *American Amateur Photographer* 6 (February 1894): 63.

Sheep, halftone, *American Amateur Photographer* 6 (February 1894): 72.

The Old Fashioned Garden, halftone, *American Amateur Photographer* 6 (March 1894): 109.

Pasadena Landscape, halftone, *American Amateur Photographer* 6 (September 1894): 401.

Sunshine after Rain, collotype, *American Annual of Photography* 1895, facing p. 154.

Off Fire Island, halftone, *American Annual of Photography* 1895, p. 227.

On the Beach, halftone, *American Annual of Photography* 1895, p. 254A.

Out for a Sail, halftone, *American Annual of Photography 1895*, p. 269A.

Seal Rocks, halftone, *Photographic Times* 26 (April 1895): 207.

From the Pasture, halftone, *American Amateur Photographer* 7 (May 1895): 195.

The Critic [Frank S. Herrmann and Alfred Stieglitz], halftone, *American Amateur Photographer* 7 (May 1895): 193.

Evening, Nassau, halftone, *Outlook* 51 (June 15, 1895): 1030.

From the Fields, halftone, *American Amateur Photographer* 7 (July 1895): 309.

Summer Days, photogravure, *Photographic Times* 27 (July 1895), frontispiece.

Evening, Nassau, halftone, *Photographic Times* 27 (August 1895): 104.

Tube Roses, halftone, *Photographic Times*, 27 (September 1895): 151.

The Fisherman, halftone, *Photographic Times* 28 (February 1896): 97.

[Lake], halftone, *Photographic Times* 28 (April 1896): 197.

End of a Winter's Day, halftone, *Photographic Times* 28 (June 1896): 266.

Idle Hours, halftone, *Photograms of the Year 1896*, p. 47.

[Frank S. Herrmann], halftone, *Camera Notes* 1 (July 1897): 7.

Landschaftstudie, photogravure, *Wiener Photographische Blätter* 4 (August 1897), frontispiece.

[Summer Days], halftone, *Wiener Photographische Blätter* 4 (October 1897): 220.

[End of a Winter's Day], halftone, *Wiener Photographische Blätter* 4 (November 1897): 234.

End of a Winter's Day, halftone, *Sunlight and Shadow: A Book for Photographers, Amateur and Professional*, ed. W. I. Lincoln Adams (New York: Baker and Taylor Co., 1897), p. 95.

Artist and Critic [Frank S. Herrmann and Alfred Stieglitz], halftone, *Photograms of the Year 1897*, p. 27.

[Cow grazing on hill], halftone, *Camera Notes* 1 (April 1898): 91.

A Pasadena Landscape, photogravure, *Camera Notes* 2 (July 1898): 29.

Sunshine after Rain, relief process print of drawing after Post's photograph, *American Annual of Photography 1898*, p. 139.

Lovewell's Pond, halftone, *Photo Era* 5 (December 1900): 168.

Intervale Winter, photogravure, *Camera Notes* 5 (July 1901): 11.

Intervale in Winter, halftone, *Second Chicago Photographic Salon* (exh. cat.), Chicago Society of Amateur Photographers and Art Institute of Chicago (Chicago, 1901), facing p. 9.

Intervale in Winter, halftone, *Photo Beacon* 13 (October 1901): 299.

Wintry Weather, photogravure, *Camera Work*, no. 6 (April 1904): 43.

The Haunt of the Deer, halftone, *Portland (Maine) Sunday Times*, June 5, 1904, p. 13.

Old Apple Tree, halftone, *Portland (Maine) Sunday Times*, June 5, 1904, p. 13.

Wintry Weather, halftone, *Art in Photography with Selected Examples of European and American Work*, ed. Charles Holme (London: The Studio, 1905), U.S. plate 14.

[Wintry Weather], halftone, *Künstlerische Landschafts-Photographie*, by Adolf Miethe (Halle, Germany: Wilhelm Knapp, 1906), p. 102.

Intervale: Winter, halftone, *American Amateur Photographer* 19 (January 1907), frontispiece.

Old Potato House, halftone, *Photo Era* 24 (March 1910): 112.

Christmas Morning, halftone, *Photo Era* 24 (March 1910): 114.

Early Spring, halftone, *Photo Era* 24 (March 1910): 115.

Lengthening Shadows, halftone, *Photo Era* 24 (March 1910): 117.

Winter Weather, halftone, *Photographic Times* 44 (March 1912): 88.

Snow Drifts, halftone, *Photographic Times* 44 (March 1912): 91.

In the Shadow of the Bank, halftone, *Photo Era* 33 (August 1914): 73.

A Bouquet of Lilies, halftone, *Photo Era* 33 August 1914): 75.

Lilies in Deep Water, halftone, *Photo Era* 33 (August 1914): 76.

Christmas Morning, halftone, *Photo Era* 33 (December 1914): 293.

Among the Foothills, halftone, *Photographic Times* 47 (April 1915): 140.

[Wintry Weather], halftone, *Künstlerische Landschaftsphotographie*, by Adolf Miethe (Halle, Germany: Wilhelm Knapp, 1919), p. 100.

Christmas Morning, halftone, *Photo Era* 46 (January 1921): 11.

BIBLIOGRAPHY

"At an Exhibition of Lantern Slides." *Photographic Times* 22 (February 26, 1892) : 110.

Barnes, Catherine Weed. "Personal." *American Amateur Photographer* 3 (November 1891): 463–64.

"The Beautiful Work of a Maine 'Photo-Secessionist' as Exhibited in the Portland Camera Club Last Week." *Portland Sunday Times*, June 5, 1904, p. 13.

Editorial Notes. *Photographic Times* 27 (September 1895): 173.

Editorial Notes. *Journal of the Camera Club* (New York) 1 (October 1896): 15.

"Fine Exhibition at Camera Club of Work of W. B. Post." *Portland (Maine) Daily Eastern Argus*, May 28, 1904, p. 8.

"Fryeburg Photographer Wins Many Foreign Honors: W. B. Post's Amateur Work Hardly Excelled by That of Professionals Here or Abroad." Unidentified newspaper, October 26, 1909. Collection of Mary Weston.

Hartmann, Sadakichi. "Exhibition of Prints by Wm. B. Post (December 1–10, 1900)." *Camera Notes* 4 (April 1901): 277–78.

Our Illustration. *American Amateur Photographer* 4 (June 1892): 263.

Our Illustration. *American Amateur Photographer* 4 (December 1892): 545.

Our Illustration. *American Amateur Photographer* 5 (March 1893): 119.

Portland Society of Art: Annual Exhibition of Photographic Section. Exh. checklist. Portland, Maine: L. D. M. Sweat Memorial Art Museum, 1912.

Post, William B. "Photographic Exhibition of the 23rd Regiment Fair." *American Amateur Photographer* 6 (December 1894): 567–68.

———. "Photography of the Snow." *Photo Era* 24 (March 1910): 112–19.

———. "Picturing the Pond-Lily." *Photo Era* 33 (August 1914): 73–76.

———. Application of W. B. Post, July 28,1887. Archives. New York Stock Exchange, New York.

———. Journal of trip to California and Japan, January 7–October 6, 1891. Collection of Mary Weston.

———. Notebook of exhibitions. "Slides and Prints in Competition," 1893–1908. Collection of Mary Weston.

———. Letters to Alfred Stieglitz, 1898–1921 (29 letters). Stieglitz Archive. Collection of American Literature. Beinecke Rare Book and Manuscript Library. Yale University, New Haven, Connecticut.

"The Post Collection of Pictorial Photographs." *Camera Notes* 2 (January 1899): 96.

"Prominent Amateur Photographers" (portrait of Post). *American Amateur Photographer* 5 (December 1893): 571.

"Remarkable Photographs: Pictures by W. B. Post at Portland Camera Club Rooms Wonderful." *Portland (Maine) Daily Advertiser*, May 28, 1904, p. 2.

"S. L. Post's Sudden Death" (father's obituary). *New York Times*, June 4,1897, p. 12.

Sale notice. "Private Sale, Fryeburg, Me., Wednesday, August 22" (handbill), 1923. Collection of Mary Weston.

Stieglitz, Alfred. Letters to William B. Post, 1894–1908 (5 letters). Collection of Mary Weston.

"A Study from Life." *Photographic Times* 19 (January 18, 1889): 25.

"William B. Post" (obituary). *Fryeburg (Maine) Reporter*, June 16, 1921, p. 1.

INDEX

This index includes only proper names. Page numbers in *italics* refer to illustrations.